NEOCLASSICAL ARCHITECTURE
in
COPENHAGEN & ATHENS

T HANSEN, VIENNA PARLIAMENT, 1874-84, NORTH PORTICO DETAIL. MEASURED DRAWING BY L O'CONNOR

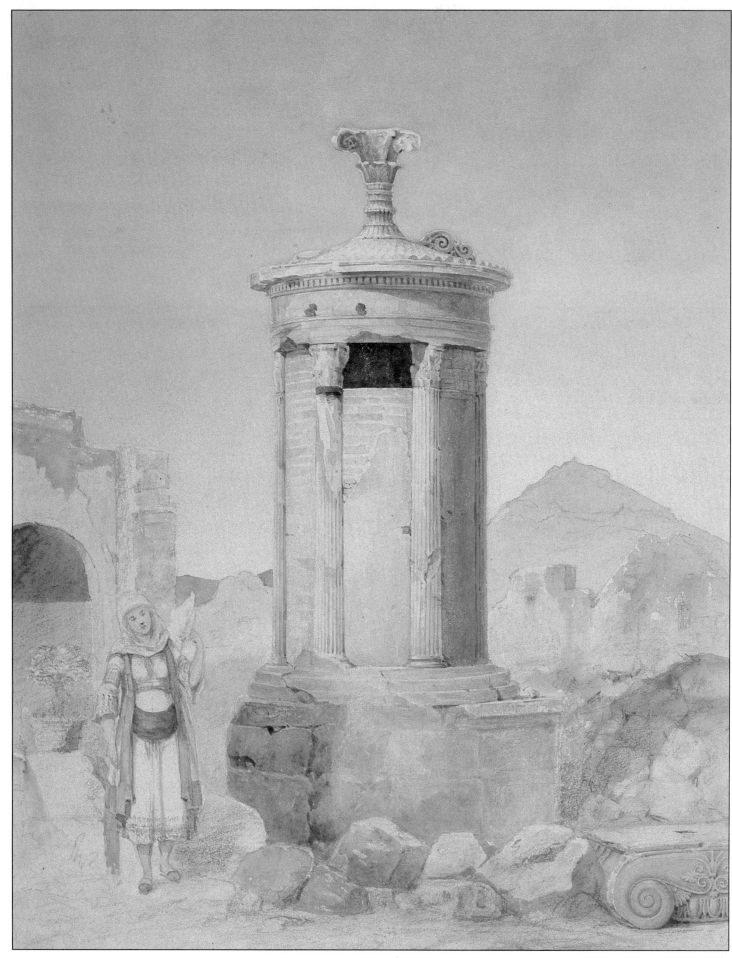

CHRISTIAN HANSEN, LYSICRATES MONUMENT (KB)

▲▶ Architectural Design Profile 66

NEOCLASSICAL ARCHITECTURE
in
COPENHAGEN & ATHENS

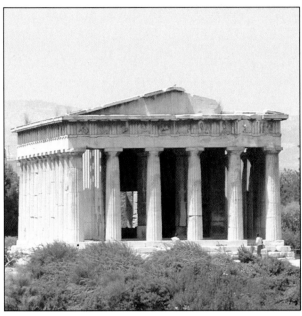

THESEION, ATHENS, 5TH CENTURY BC

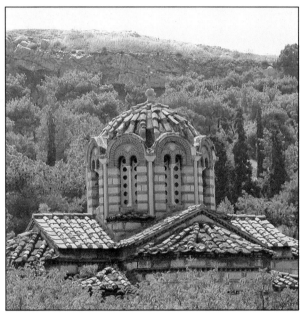

CUPOLA OF BYZANTINE CHURCH

Guest Editors
Lisbet Balslev Jørgensen & Demetri Porphyrios

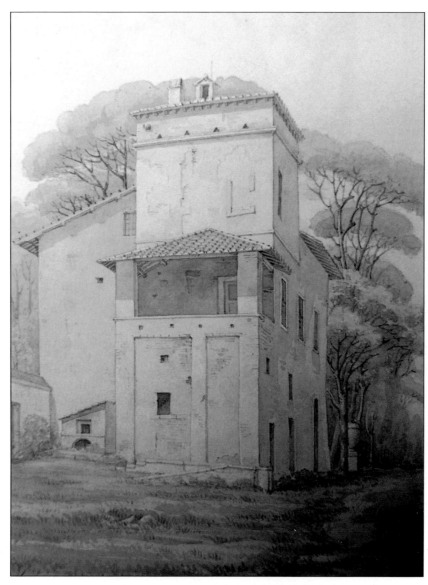

CHRISTIAN HANSEN, GARDENER'S HOUSE AT VILLA BORGHESE, ROME, 1832

Editor: Dr Andreas C Papadakis

First published in Great Britain in 1987 by *Architectural Design*
an imprint of the
ACADEMY GROUP LTD, 7 HOLLAND STREET, LONDON W8 4NA

Architectural Design Profile 66 is published as part of *Architectural Design* Volume 57 3/4-1987
Distributed in the United States of America by
St Martin's Press, 175 Fifth Avenue, New York 10010

ISBN: 0-85670-887-9 (UK)
ISBN: 0-312-18223-6 (USA)

Design Layout: Aliveza Sagharchi

Printed in Great Britain by E G Bond Ltd, London

Abbreviations used for photographic credits

KB Kunstakademiets Bibliotek, Copenhagen (Royal Academy Library); **SRM** Suomen Rakennustaiteen Museo, Helsinki (Museum of Finnish Architecture); **GL** Gennadeios Library, Athens; **AE** Library of the Archaeological Institute, Athens; **AK** Akademie der Bildende Künste, Vienna; **AB** *Allgemeine Bauzeitung*; **NA** *Neoclassical Architecture in Greece*, by J Travlos; **TH** *Theophilos Hansen und Seine Werke*, by Niemann and Feldegg, Vienna; **CH** *Samling af forskjellige offentlige og private Bygninger*, by C F Hansen; **CFA** C F Hansen's Album in the Kunstakademiets Bibliotek, Copenhagen; **DK** *Die Kunst*, May 1942; **BM** Benaki Museum, Photographic Archives, Athens

INTRODUCTION
Demetri Porphyrios

THE IMPACT OF THE NEOCLASSICAL MOVEMENT at the beginning of the nineteenth century brought about a transformation of Western European culture that was regarded by contemporaries as a rebirth of antiquity. But while the history of nineteenth-century Neoclassicism is pre-eminently international history, that is history without frontiers, it is also comparative history. For each cultural region generated, received and transmitted the innovations of the day and developed particular forms and institutions to foster the new impulses.

The rebuilding of modern Athens must be counted as one of the significant achievements of Neoclassical architecture. This was the work of a group of German, French and Danish architects – Klenze, Schaubert, Ross, Christian and Theophilos Hansen, Gärtner, Weiler, Koch, Stauffert, Boulanger, Ziller, and later the Greeks Kalkos, Kleanthis and Kaftanzoglou were some of the architects responsible for the rebuilding of modern Athens between 1830 and 1900.

The work of the Hansen brothers, however, dominated that of their companions and established them as leaders in the search for a modern 'Hellenic' architecture. It is not the least measure of their leadership that they never discouraged the talent of others; and while they may have aroused the envy of some no one could deny that they acted as a stimulus to those around them.

The inspiration of the Hansen brothers was essentially personal but their lust for the revival of antiquity must be appraised within the general context of nineteenth-century European romanticism. In the case of the Greek struggle for independence (1821-30), the rise against the Turks was plausibly identified with the cause of the liberal European bourgeoisie. Philhellenism was a major social and cultural movement which, during the 1820s, spread in European centres such as Munich, Leipzig, Berlin, Paris and London. Philhellenism, of course, had taken root much earlier among the cosmopolitan Greek diaspora as was the case with Rhigas (1760-98) and the secret patriotic society *Philiké Etaireia* founded in Odessa in 1814. Once independence was won, the appointed King Otto of Greece set out to reconstruct the newborn nation along the philhellenic lines of German romanticism. Armed with enthusiasm and confidence, the architects who implemented his ideas aimed at creating a modern Greece of civic splendour.

It is here that the contribution of the Hansen brothers proved of seminal importance for the development of Neoclassicism in Greece. The monumentality of imperial Prussian Neoclassicism gave way to the simple, domestic, homely strain of such brilliant works as the University, Observatory or Academy of Athens. Both Christian and Theophilos Hansen were always at ease with the indigenous painted and brushed render and it is not hard to see that they valued rustic simplicity more than marmoreal European sophistication. Their command of proportion, composition, texture and detailing compels admiration. Partly this is the direct consequence of choosing as their models exclusively Greek classical sources; partly it is the expression of a very real enthusiasm for the antique world which had inspired the supreme examples of their architecture.

To the question of whether they believed in pagan gods and spirits, overlooking the social and technological realities of their time, one can surely reply with an unequivocal negative. Christian and Theophilos Hansen viewed Greek architecture and art much as Schiller and Goethe or much earlier Trissino and Ariosto saw classical literature: as a repository of paradigms for inspiration from which one had to make something new.

In the Greece of the 1830s and '40s there was another paradigm which required re-evaluation: the Byzantine tradition. The question was whether there could be a marriage between antiquity and Byzantium with the aim of preserving the best of pagan wisdom while reconciling it with Christian truth. Theophilos Hansen attempted to reconcile the noble severity of classical antiquity with the plastic and textural idiosyncracies of Byzantine architecture, but for the most part the Byzantine tradition proved the least amenable to syncretic treatment. For one thing, Byzantine architecture had become too closely identified with ecclesiastical architecture, and for another it lent itself with difficulty to adaptations necessitated by nineteenth-century building programmes and technology.

*　　　*　　　*

This volume is *not* a comprehensive survey or a definitive critical evaluation of Neoclassical architecture in Copenhagen and Athens. Such a book has yet to be written. Instead, when I undertook to edit this volume I chose to focus on the work of Danish architects in Athens. However some background of their activities outside Greece was necessary and as such I chose to illustrate a few of their seminal buildings in Copenhagen and Vienna.

In the first part of this volume, Lisbet Balslev Jørgensen presents the historiography of the Copenhagen School of Classicism and Ida Haugsted gives an account of the work of the Danish architects Christian Hansen, Theophilos Hansen and Gottlieb Bindesbøll in Athens, Vienna and Copenhagen. The second part of this volume comprises a number of selected projects by Danish Neoclassical architects with an emphasis on the work of the Hansen brothers in Athens. Most of the photographic material is published here for the first time in such a comprehensive manner. I would like to think that the buildings illustrated become a source of inspiration and *not* of mere parody and mimicry. Let us not forget that the achievement of Danish Neoclassical architects was their ability to transform the classical language without submitting it to parodic inversions.

*　　　*　　　*

I would like to thank Lisbet Balslev Jørgensen for her collaboration and unfailing support throughout the preparation of this volume. I am also thankful to Ida Haugsted who collaborated on this issue, Margit Bendtsen, Liam O'Connor who helped with the photographic research, and Alireza Sagharchi who worked on the layout. I am grateful to all the institutions, libraries, archives, periodicals, and persons mentioned in the photographic credits as well as to the Trustees of the V&A Museum for their help and assistance in collecting the photographic material. My thanks also extend to Pamela Johnston and Clare Melhuish who made this volume possible through their technical and editorial assistance.

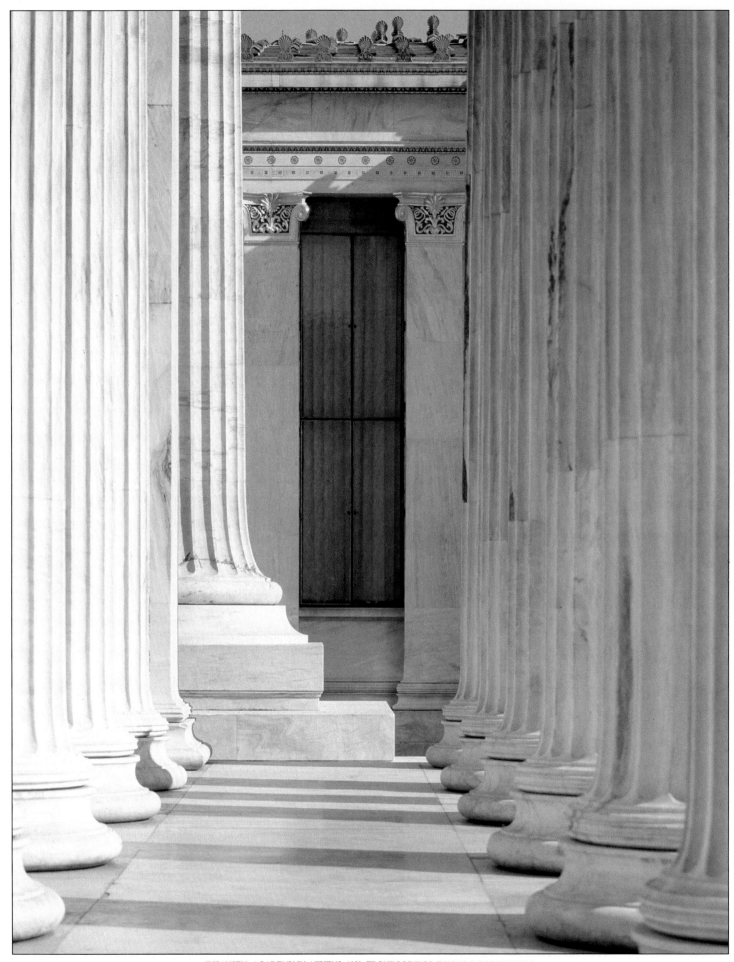

T HANSEN, ACADEMY IN ATHENS, 1859, FRONT PORTICO (PHOTO D PORPHYRIOS)

THE COPENHAGEN SCHOOL OF CLASSICISM

Lisbet Balslev Jørgensen

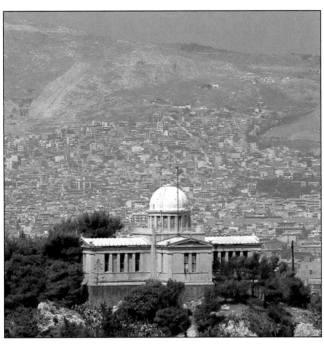

T HANSEN, ATHENS OBSERVATORY, 1842-46 (PHOTO D PORPHYRIOS)

ENMARK'S KING FREDERIK V OFFICIALLY founded the present Royal Academy of Fine Arts in Copenhagen in 1754. His aim was that the Academy would educate his Danish, Norwegian and other subjects in the Arts. It was vital for the King that his artists should be recruited from among his own people and that his architects and craftsmen should create an architecture that would prove to the world that his land was a glorious part of European civilisation. The Academy was fashioned according to the principles of the Académie des Beaux-Arts in Paris. The French sculptor Jacques-François-Joseph Saly (1717-76) was asked to submit ideas *'pour la perfection et le progrès de l'Académie'* and, some years later, as its director, he declared: *'La France doit à François I l'avantage d'avoir attiré et cultivé les Beaux-Arts. Le Nord, Sire! devra ce bonheur à Votre Majesté.'*[1]

The new architecture was brought to Denmark by Nicolas-Henri Jardin (1720-99) from the French Academy in Rome. It was based on the research and findings of classical archaeologists and architects and on their interpretation of classical antiquity. Denmark, however, much like Rome, felt the need for a glorious past that would buttress its national consciousness. The Swiss-French Paul Henri Mallet (1730-1807) was called in by the King to teach French at the Academy and soon thereafter published his *Introduction à l'Histoire de Danemarc* and *Monuments de la Mythologie et de la Poésie des Celtes*. In his Introduction Mallet explains that: *'if we seriously want new results it is necessary to make new observations. In moral and political matters it is the only way to find the truth. We must study the language, books and customs of people from every period and from every region and search for information about the various nations in genuine sources. In the course of such studies the ties that unite the different parts of Europe will emerge stronger and stronger every day.'* The Temple and the Dolmen therefore were seen as different stages in the evolution of one and the same idea –

an attitude which continued to pervade academic education for many decades. At the same time, the Enlightenment belief in scientific progress introduced optimism about the future that allowed both kings and politicians to be visionary. The present could conquer the past. Copenhagen was to become the metropolis of the North. Danish art and architecture could even conquer Rome and turn the glorious past into a glorious present.

The first important Danish architect to receive the Gold Medal of the Copenhagen Academy was Caspar Frederik Harsdorff (1735-99). Returning from his travels abroad, he applied for membership in 1765, submitting a perspective for an Ideal Piazza with a Royal Palace. This project demonstrates that Harsdorff had learned a lot from his travels to Paris and Rome and that he was now a classicist well advanced from his former teacher in Copenhagen. The perspective is indebted to Gabriel's Place Louis XV (Concorde), as well as to the Piazza del Campidoglio, but the taste has been enriched with newly discovered and measured motifs from Rome. This drawing was certainly meant to give the King an idea as to what he should ask from his new architect. As a site, Harsdorff might have had in his mind Kongens Nytorv where the Charlottenborg Palace and the Royal Theatre were situated. An equestrian statue was already there, but the buildings did not form a noble space worthy of an absolute monarch. The project was meant to show the new trend in academic education and emphasise the evolution of classical architecture since the Roman Empire. Like every student of the Academy, Harsdorff believed that the noble grandeur of architecture was to be found among the antiquities of Rome and Greece and that the only way to disclose the secret of true proportions was to study and measure the best buildings of classical antiquity. And though the authority of Palladio and Vignola was greatly diminished, their books were still studied. Harsdorff owned a copy of the *Quattro libri dell'architettura* and he had Vignola at his fingertips.[2]

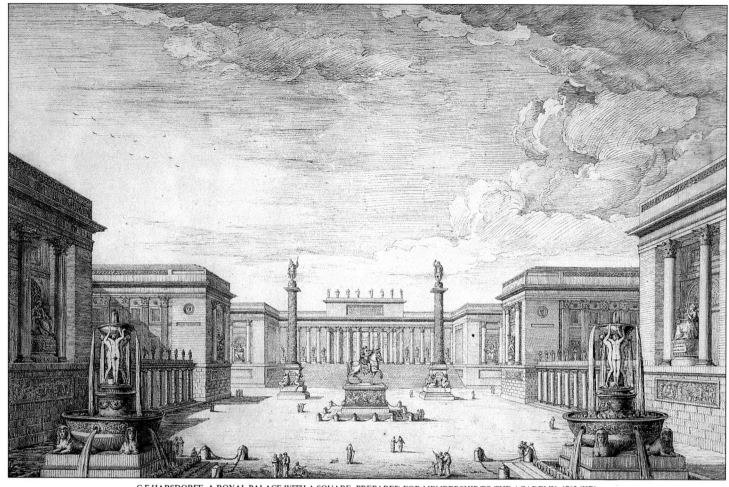

C F HARSDORFF, A ROYAL PALACE WITH A SQUARE, PREPARED FOR MEMBERSHIP TO THE ACADEMY, 1765 (KB)

Harsdorff's Ideal Piazza remained on paper. However, when some new regulations were applied to Kongens Nytorv, Harsdorff himself took the initiative and in 1780 built a residence next to Charlottenborg Palace. Twelve years later he was commissioned to build a new facade for the Royal Theatre and in 1801 his scheme for a private palace next to the theatre was built. Harsdorff arranged the facades in such a way as to create a closed space. The urban scene of Kongens Nytorv, however, was never completed and later changes and competitions did not succeed in giving a spatial coherence to this fragmented square – although Harsdorff's residence with its pediment on Ionic pilasters set a fashion for many private houses in Copenhagen and the provinces.

From 1771 onwards craftsmen had access to the Academy and new primary and secondary courses were established. The primary course started with the orders and other compositional rules of architecture. Apprentices were taught how to execute drawings of porches, mouldings, ornaments, etc, for a simple house. Thus the latest trend in 'good taste' spread quickly to all parts of the country. The civic archives of the various Danish towns show even today that the drawing skills and ornamental motifs used by these craftsmen can be traced back to Harsdorff and the French Academy in Rome. To qualify for the academic school proper, carpenters and masons had to sit examinations in mathematics, history and their mother tongue – at that time Danish, Norwegian or German. This system placed the architect at the top of the hierarchy of craftsmen. In the 1850s, Technical Schools were responsible for the instruction of craftsmen and a certificate from them qualified the holder for entry to the School of Architecture. Still today, the School of Architecture is considered part of the Academy of Fine Arts and has no relationship to the School of Engineering; an acknowledgement of the fundamental difference in their fields of activity. At the same time the architect continues to cultivate his interest in craftsmanship and traditional materials.

By the time Christian Frederik Hansen (1756-1845) had finished his studies in Copenhagen, Rome had replaced Paris as the centre of architectural culture. In 1779 he was awarded the Gold Medal and went to Italy to study Palladian and Roman architecture. During his last student years, Hansen had worked for his teacher C F Harsdorff on the sepulchral chapel of Frederik V at Roskilde Cathedral. Harsdorff had prepared the drawings for the sepulchral chapel in 1763, while in Rome, and when he was awarded the commission in 1776, he made a few necessary technical changes. At the same time he emphasised the geometrical simplicity of the building according to classical principles. C F Hansen was involved in the building work from the very beginning and from 1780 onwards as a surveyor. In fact, it was he who completed the work in 1823 long after Harsdorff's death and it was said that he added to its

N ABILDGAARD, APIS TEMPLE, COPENHAGEN, 1802-04 (PHOTO L B JØRGENSEN)

KONGENS NYTORV, COPENHAGEN, C 1870. C F HARSDORFF, ROYAL THEATRE, (1792), AND ERICSEN'S PALACE, (1799) (KB)

beauty.[3] This sepulchral chapel turned out to be Harsdorff's master-piece. Its brickwork, its simple volumes and the impressive serenity of the interior continue to be sources of inspiration for Danish architects.

Both Saly and Jardin had been invited to work on the new town of Frederiksstaden. Saly was asked to design the equestrian statue of Frederik V while Jardin was to complete Frederik's Church follow-ing the designs of Nicolai Eigtved. Harsdorff was a student of Jardin and he later freely acknowledged that Jardin was the first artist to introduce to Denmark the usable simplicity of antiquity and there-by obliterate bad taste.[4] The construction of Jardin's church was never completed. It became a 'Roman ruin' and for the next hundred years its completion was seen as a challenge to every ambitious architect. Harsdorff's proposal of 1797 was a veritable

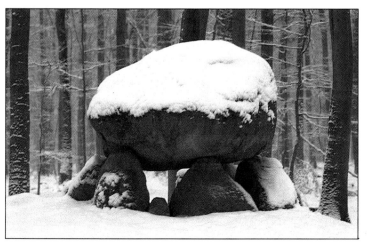

DOLMEN, SEALAND, DENMARK (PHOTO L B JØRGENSEN)

Pantheon: he simplified and changed the plan to obtain the sublime grandeur of the Roman rotunda; 'a space of mysterious beauty'. His scheme was not realised but his drawings and the model which still exist – showing the only Pantheon-like 'building' Copenhagen ever had – became an inspiration for generations of academy students who, looking into it through the floor, experienced the magic light coming through the oculus.[5] Some of them learned that light creates space. Harsdorff's contemporary critics pointed out that his portico, following Roman precedent, should have been in the Corinthian rather than the Ionic order. Harsdorff believed, however, that the Greeks, from whom good taste originated, most often used the Doric order;[6] and since the Doric order must have been too 'rough' for his taste, he opted for the Greek Ionic order. Harsdorff, unlike Goethe, could not come to appreciate the Doric order. Goethe, whose eye was accustomed to a lighter architecture, was initially repelled by the stubby Doric columns – 'doch nahm ich mich bald zusammen, erinnerte mich der Kunstgeschichte, gedachte der Zeit, deren Geist solche Bauart gemäss fand'. Thus when he first encoun-tered Greek architecture, he thanked destiny for bringing him to Paestum.[7]

In spite of the economic boom of the period and two major fires – one that struck Christiansborg Palace in 1794, the other the city at large in 1795 – Harsdorff was never given the opportunity to carry out a larger project. The reconstruction of the damaged city was left to C F Hansen who, following the English bombardment of 1807, was also asked to prepare proposals for the reconstruction of the Cathedral. The gloomy and lurid gothic was to give way now to the 'good' taste of the Enlightenment.

During his stay in Rome C F Hansen, like his fellow students, realised that the buildings of antiquity, though stripped of their ornament, had an impressive and dramatic effect. Simplification and naturalness were the new concepts. Architecture was meant to help man conceive nature's greatness before which even an abso-

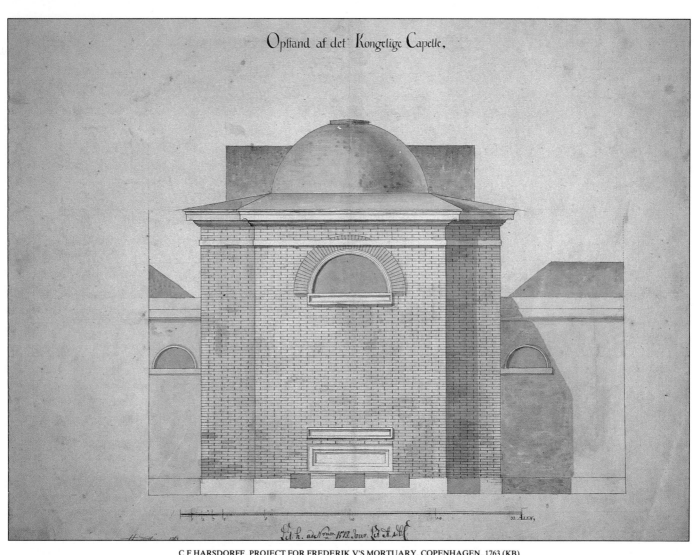

Opstand af det Kongelige Capelle.

C F HARSDORFF, PROJECT FOR FREDERIK V'S MORTUARY, COPENHAGEN, 1763 (KB)

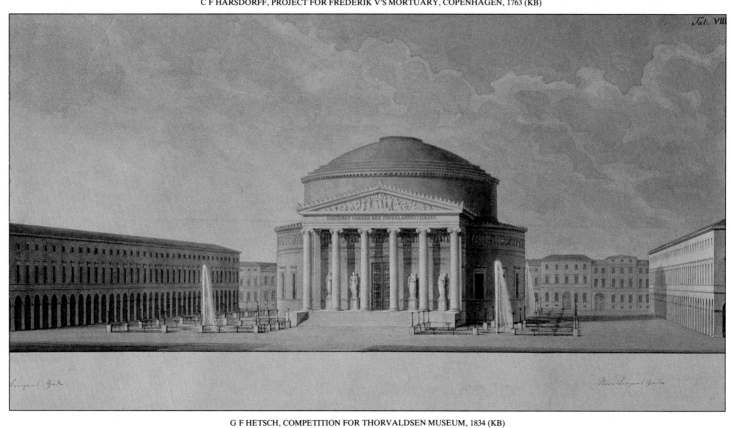

G F HETSCH, COMPETITION FOR THORVALDSEN MUSEUM, 1834 (KB)

G F HETSCH, PRIVATE HOUSE, COPENHAGEN, 1849 (KB)

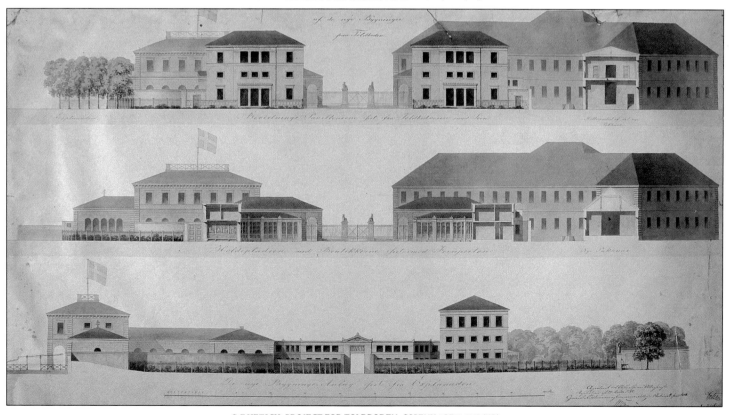

G F HETSCH, PROJECT FOR TOLDBODEN, COPENHAGEN, 1847 (KB)

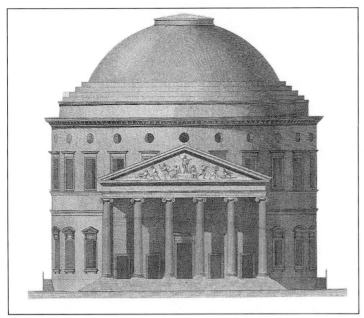

C F HARSDORFF, PROJECT FOR FREDERIK'S CHURCH, COPENHAGEN, 1797 (KB)

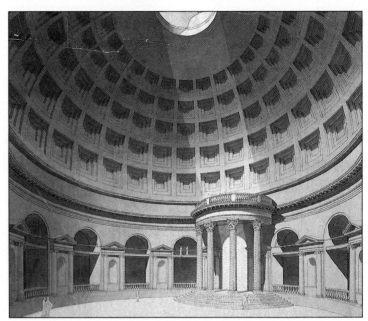

C F HARSDORFF, PROJECT FOR PANTHEON, COPENHAGEN, 1797 (KB)

lute king had to abject himself as mankind stood in awe of the Sublime. Primary solids such as the cube, the pyramid and the cylinder were considered 'natural' forms, each representing an idea. Etienne-Louis Boullée maintained that a single dominating primary form represented the ultimate synthesis of a philosophical system. Similarly, the Frenchman Joseph-Jacques Ramée (1764-1842), who came to Denmark, used such primary forms in his design for an altar celebrating the anniversary of the Revolution,[8] while the villas he built in Copenhagen in 1802-05 were based on the juxtaposition of cubic forms under separate roofs.[9]

The Newtonian understanding of the universe, popularised by Voltaire, argued for a universe that was measurable and intelligible to reason. In this context the genius of man was a force of nature. This message contained a new morality which was soon formulated in legislation and made visually manifest in the arts. Portraits depicted honest and industrious men and women. The Greek Doric column was no longer thought to be stubby but strong and manly. And from 1814 onwards, only a year after the bankruptcy of the Danish state, every child was given the right to go to school. It was in that context that C F Hansen prepared his proposals for the 'Frue Plads'. The Church of Our Lady in the middle of the square was rebuilt between 1808-29. The Latin School, completed in 1815, occupied the east side of the square and its elevation facing the Pantheon-like apse of the church was as severe as the disciplinary rules of the educational system: *Studiorum Severitate Fingitur Ingenium*. On the south side of the square there was a charitable institution (1812) as well as residences; all expressing strength, piety and discipline. The primary forms complemented each other: the *Idea* in the centre emphasised by a background of surrounding buildings.[10] Clearly indebted to the square around the Roman Pantheon, this scene was to be repeated by G F Hetsch in his first project for the Thorvaldsen Museum of 1834 as well as by Peder Vilhelm Jensen-Klint in his Grundtvig's Church of 1919-30.

For his Courthouse and Gaol complex C F Hansen chose more dramatic facades. The Ionic portico of the Courthouse is impressive, for it was meant to inspire respect for the law and confidence in justice. By contrast, Slutterigade with the prison was meant to discourage the most inveterate creature from committing a crime. The architecture, of course, suggests that Hansen must have been familiar with the works of C N Ledoux.

C F Hansen's son-in-law was Gustav Friedrich Hetsch (1788-1864), an architect who introduced new ideas to Danish architecture other than those of the Enlightenment. G F Hetsch was educated in Stuttgart and worked for four years in Paris in the atelier of Charles Percier. He then went to Rome where he stayed between 1812 and 1815.[11] In 1815 he arrived in Copenhagen to work for C F Hansen on the interior decoration of Christiansborg Palace. In the same year the Danish architect Peder Malling returned from Rome where the sculptor Bertel Thorvaldsen – 'the Danish Praxiteles' – was enjoying tremendous success. Greece and Pompeii were now the true sources of inspiration. In 1815 Antonio Canova saw the Elgin marbles in London and told the world that Phidias' work was '*la bella natura*'.[12] In 1816 Thorvaldsen accepted a commission to restore the Aegina marbles for Ludwig of Bavaria.[13] These two masters – Thorvaldsen and Canova – had now experienced the 'pure nature' of Greek art. Thorvaldsen was an important contact for Danes visiting Rome. In his studio at Piazza Barberini and through his library and collections they were introduced to the latest artistic developments. Thorvaldsen and K F Schinkel thought highly of each other and both men were of the opinion that art and architecture were of equal value. Schinkel's display of paintings in the Berlin Altes Museum emphasised this. Thorvaldsen, for his part, fought a battle in 1821 against C F Hansen when he refused to engage his statues of the Apostles into the nave pillars of the Church of Our Lady. And in 1824, when Thorvaldsen and Schinkel collaborated on the design of the tomb of Pius VII in St Peter's, Rome, they produced numerous sketches which bear witness to the difficulty of incorporating Thorvaldsen's additive composition into the dynamic scenery.[14] Thorvaldsen believed that architectural elements should be juxtaposed with sculptures and paintings on an equal basis: only then was the idea complete and the 'mistakes' of a dynamic scenery eliminated. It is understandable, of course, how in a country like Denmark with a vernacular tradition in timber construction, the additive method of composition must have felt 'natural'. That must also explain the popularity of J N L Durand's *Précis des leçons*, the 1823-25 edition of which served as a primer in additive composition.

C F Hansen ruled the Academy until 1833 when the individualism of the new middle class began to challenge him. He lost the commission for the University building at Frue Plads to his former student and assistant, Peder Malling (1781-1865), the architect of Sorø Academy (1822-27). Malling's motif for the main entrance was a triumphal arch with an eagle beholding the heavenly light. The stairs are as steep as those of the Propylaea, the door handle is positioned high up and '*per aspera*' the student will reach the stars. The decorations in the vestibule depict the origins of European culture in ancient Greece and those in the assembly hall picture the history of Denmark.[15] In fact, there had been a debate as to whether Danish history alone should have been the subject of the wall

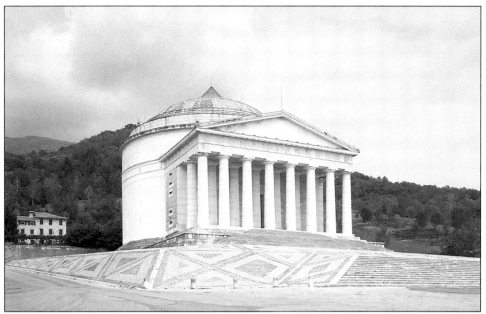

G SELVA WITH A DIEDO, TEMPIO DEL CANOVA, POSSAGNO, 1819-33

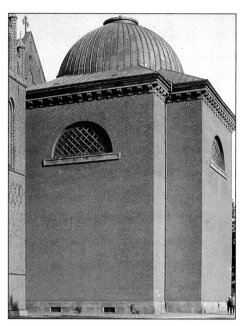

C F HARSDORFF, FREDERIK V'S MORTUARY, 1763 (KB)

frescoes but many had indeed insisted that Greek mythology was indispensable. Both students and citizens contributed towards the cost of the marble statues of Apollo and Athene. In a true democracy the people themselves are the patrons. Before Denmark even became a constitutional democracy (in 1849 and without a revolution) the first architectural monument to the new democracy was built – Thorvaldsen's Museum.[16] In 1834 the Copenhagen Art Association announced a competition for a museum on the site of Frederik's Church and everybody knew that it was a museum for the sculptor Thorvaldsen that they had in mind. Professor Hetsch submitted a scheme recalling the Pantheon in Rome. His young student Michael Gottlieb Bindesbøll (1800-56) – who was eventually entrusted with the commission – had also prepared drawings. His sketches, dating from the same year, feature the Erechtheum Caryatids. Bindesbøll, however, having been awarded the Academy's travelling fellowship, left for Rome in 1834.

In Rome Bindesbøll continued to work on his designs for the museum in direct consultation with Thorvaldsen. The sculptor wanted a simple building with small rooms that offered studio lighting. From the very beginning Bindesbøll conceived the museum as a polychromatic edifice since: '*Colour unites all times and all people*'.[17] But Rome also showed him that it was possible to mix Roman, Greek and Egyptian styles: in that sense, the Borghese Gardens was 'a catalogue' of history. The Danish author Hans Christian Andersen had described the 'Spirit of the Age' in his account of visiting Vesuvius during an eruption: there he witnessed the creation of the world and the destruction of Herculaneum and Pompeii. But time was not important. The noble life of Pompeii and ancient Greece could continue as if never interrupted. With the help of historians, archaeologists, artists and architects the noble life of antiquity could continue in Europe and find a firm footing in Copenhagen.

Bindesbøll and Thorvaldsen would see to that. In 1835, Bindesbøll went to Greece to meet his friend Christian Hansen who had just been appointed architect to the King of the Hellenes. On the Acropolis Bindesbøll studied every polychrome fragment he could find and copied them all with great accuracy. The red, blue and green of antiquity he used later in his museum. But he found also that the colours in Pompeii and Constantinople were the same. Mallet had told the truth: the ties that united the different parts of Europe grew stronger every day. Out of the soil of Athens would rise a new architecture that was to spread throughout Europe. While the measured drawings of Stuart and Revett were indispensable, everybody had to see and measure the monuments of antiqui-

ty for himself and this contributed to the knowledge of the '*bella natura*' of architecture.

Greece had another face to it. Bindesbøll – like Christian Hansen – saw that the Byzantine churches and cloisters of Christian Greece were as much a part of contemporary Greece as were the temples on the Acropolis. Byzantium represented the origins of Christianity and its architecture had to be acknowledged as well. It seemed, therefore, quite natural to build a classical and a Byzantine house next to one another.

When Hans Christian Andersen visited Athens in 1841, he 'saw the city growing' and wrote in his diary that the colours and forms of the mountains were much more beautiful than those of Italy. The brothers Christian and Theophilos Hansen introduced Hans Christian Andersen to Athens and described Christian Hansen's school for craftsmen and how eager Greek peasants and soldiers were to learn the art of drawing.[18] In Greece as well as Denmark, it was important that the people themselves raised their own monuments!

When Bindesbøll returned to Rome in 1837, he designed an ambitious project to impress the museum committee in Copenhagen with a demonstration of his skills. The front elevation recalled Schinkel's Altes Museum in Berlin. The rectangular peristyle of 118 columns enclosed a small temple dedicated to Christ and the twelve Apostles.[19] Thorvaldsen's sculptures were to be displayed in the open colonnades which were polychromed in the newly rediscovered reds and blues of the Acropolis monuments. And though this project was not realised, it influenced the ideas that Christian and Theophilos Hansen formulated for the architecture of the newly founded Greek State.

Bindesbøll's final project dating from 1839 was a simple conversion of the Royal coach-house next to C F Hansen's Christiansborg Palace. However, the symbolic language and historic references used are opulent. Motifs from Rome and Athens are combined with metaphorical decorations that depict the story of human life: in this case Thorvaldsen's glorious life. The building reaches its climax in the decoration of Thorvaldsen's tomb. The burial chamber illustrates a Grundtvigian hymn inspired by Thorvaldsen's death: *Let go the black cross and where it stood may lilies grow*. Which meant: Thorvaldsen's fame will never die and by his example classical heritage will pass on to future generations.[20] This was to become the proudest monument of the North, and like Antonio Canova's Museum in Possagno,[21] Thorvaldsen's Museum '*was comparable to the Roman Pantheon and the Acropolis in Athens*'. In this building the genius of Greece met that of Rome and was brought to life in Copenhagen. Indeed the museum captured the nation's imagina-

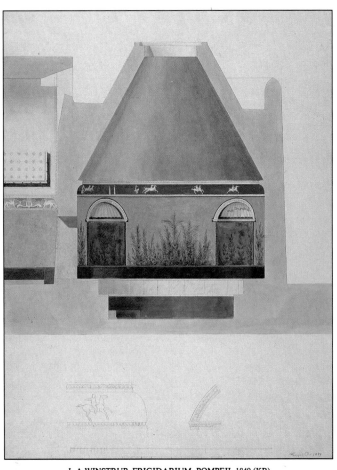

L A WINSTRUP, FRIGIDARIUM, POMPEII, 1849 (KB)

M G BINDESBØLL, ANTEFIX FOUND AT THE ACROPOLIS, 1836 (KB)

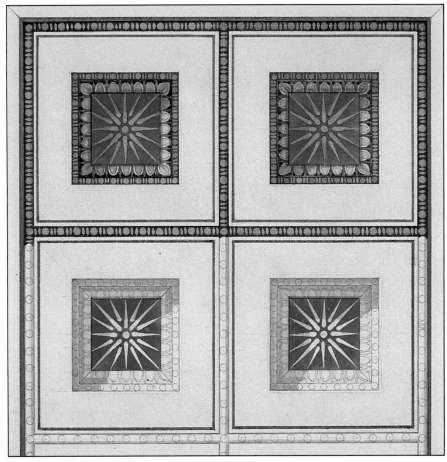

CHRISTIAN HANSEN, COFFERS FROM THE THESEION, ATHENS, RECONSTRUCTION, 1837 (KB)

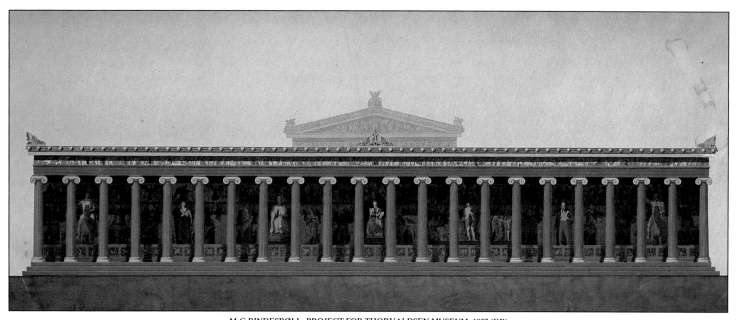

M G BINDESBØLL, PROJECT FOR THORVALDSEN MUSEUM, 1837 (KB)

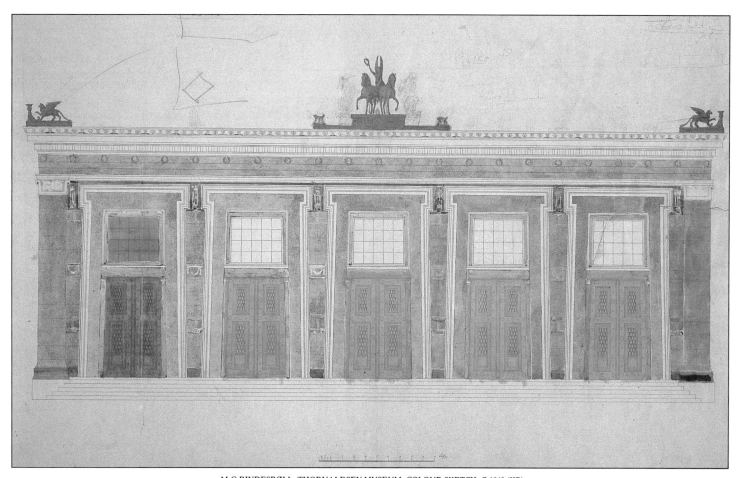

M G BINDESBØLL, THORVALDSEN MUSEUM, COLOUR SKETCH, C 1840 (KB)

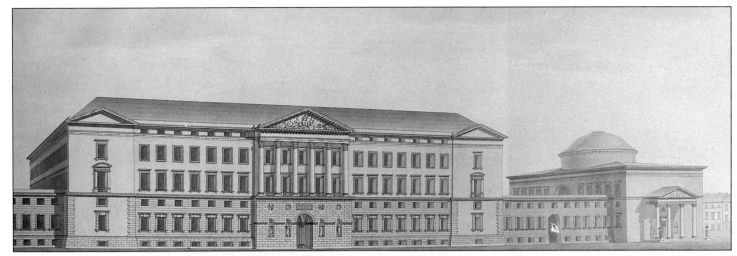

C F HANSEN, CHRISTIANSBORG PALACE AND CHAPEL, 1803-28 (CFA)

tion and was financed by the people of Denmark. It became a symbol of democracy and stimulated the cultivation of craftsmanship and indigenous art.[22]

In domestic architecture, the picture was very different. The demands of the new middle class for comfort and a sense of individuality ruled out symmetry and formal composition. Instead, Italian vernacular became the inspiration for the design of private villas. Small houses of the Italian countryside filled the sketchbooks of Danish architects for future use in their homeland. These vernacular houses seemed so natural; as if shaped by laws of nature that reigned for hundreds of years. Summer houses, however, were allowed to be more eclectic than villas. Leisure was understood as making a retreat from civilisation in the 'Villa Bella Vista' or 'Thalassa'. The setting, therefore, was meant to recreate a make-believe world of Mediterranean blue sky with no trace of the Dolmen-like clouds of Nordic summers. It was also at this time that interest in the aesthetics of the 'solitaire' increased, inspired by the classical temples of Sicily and the Byzantine cloisters outside Athens. The art of siting buildings in the landscape had aleady been discussed by C C L Hirschfeld in his *Theorie der Gartenkunst* (1779-85). But it was not until the aesthetics of the 'solitaire' were popularised that landscaping became part of the curriculum.

In 1884 Christiansborg Palace was once again destroyed by fire. The walls remained standing and the church had been saved but nobody cared about C F Hansen's architecture. Instead, Theophilos Hansen was asked to submit designs for the restoration of Christiansborg Palace. He made the heavy facades lighter by using Corinthian and Ionic columns and disengaged Thorvaldsen's statues from the wall. And when in 1885 he was told that the restora-tion would not go ahead, he tried once again to secure a commission in Denmark by submitting drawings for a Parliament, this time in a free Byzantine style.

Theophilos Hansen was of the opinion that the Hellenic style – which he had developed from his study of Schinkel and Semper but above all from his own archaeological studies of the Greek monuments – was the very best.[23] Second best was the Byzantine style. But he insisted that beauty in architecture depended on proportion and that the secret of proportion was to be found at the Acropolis. His Austrian biographer saw his genius as naive; meaning that his creative imagination was never disturbed by philosophical or intellectual abstractions. In fact, Thorvaldsen was often described by his friends in a similar manner. Both men seemed to represent the human force of nature before the Fall! Their creativity sprang from the heart and not from intellectual reflection. Following his work in Vienna, however, Theophilos Hansen's critics regretted that he had lost his earlier innocence by confusing richness with artistic quality; something which to a protestant soul was an indubitable sin. Theophilos Hansen's last project for Copenhagen, an urban plan for the whole area of Slotsholmen, was destined to remain on paper. But we see in this project his all-encompassing vision: the Parliament, C F Hansen's church and Thorvaldsen's Museum were all Hellenised. Similarly, his last project from 1888, a museum for Athens, 'the most important of all cities', was nourished by the Hellenic spirit.

* * *

In what style shall we build? The passage of time could not be

J D HERHOLDT, PROJECT FOR A VILLA, 1851 (KB)

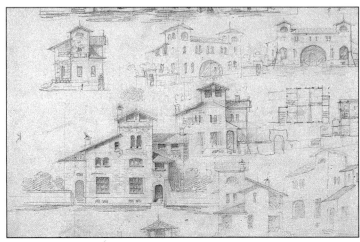

J D HERHOLDT, VILLAS FOR FREDERIKSBERG, 1857 (KB)

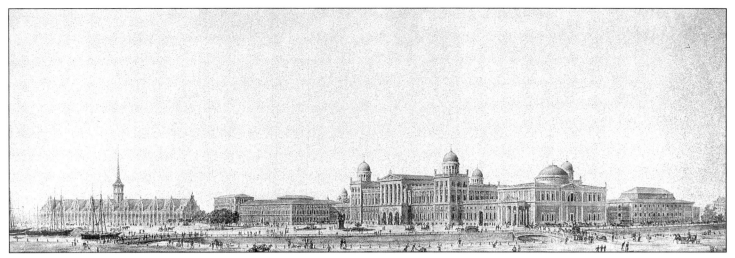

T HANSEN, SLOTSHOLMEN, COPENHAGEN, PROPOSED RESTORATION, 1887 (J LÖWY, VIENNA)

ignored. Eternal truth in architecture did not exist. Truth had to be searched for and formulated again and again.

Carl Petersen's (1874-1923) Faaborg Museum, built in 1912-15, marked a new era of twentieth-century Neoclassicism. Like Bindesbøll, Carl Petersen could discuss his work with a sculptor, in this case his friend Kai Nielsen. Petersen recalled the years he spent at the Sorø Academy as a boarder: '*Peder Malling's classicist house with its clear plan and wonderfully simplified mouldings and decorations . . . even the most spartan room was proportioned harmoniously. Dalsgaard's – my teacher's – room [had] cobalt-blue walls . . . it is the most beautiful colour I know*.' At the School of Architecture in Copenhagen, Carl Petersen learned that the Greek temples were painted in pure, bright colours. In 1901, at the National Exhibition of Arts, he saw C F Hansen's and M G Bindesbøll's drawings, C F Harsdorff's Pantheon-like model and paintings by their contemporaries.[24] He realised that all these artists formed an organic whole because they had a common vision. Thorvaldsen's Museum and C F Hansen's buildings became his paradigms: in them he saw Rome and Athens in Copenhagen. He learned how light and shadow modulate space and studied the effects of form, texture and colour in space. But it was necessary that he and his contemporaries had a common vision as well. Like Bindesbøll, he had to be congenial with his artist friends. The sources of inspiration for his Faaborg Museum are clear: the Palladian window in the tower of Our Lady becomes the entry to the museum; the mosaic floors and painted walls are reminiscent of Thorvaldsen's museum; and Carl Petersen had certainly studied Harsdorff's model. The vision, however, is new, with harmony being replaced by an inner tension as in the sculptures of Kai Nielsen. Petersen described his artistic aims in three lectures given between 1919 and 1922 at the Academy under the title 'Contrasts, Textures and Colours'.[25]

The international classicism of C F Hansen was now seen to represent the 'justice of the Roman republic'. The architecture of Copenhagen, therefore, bore the character of classical simplicity. Blocks of flats stripped of all the exuberance of historicism were now meant to represent social liberation and democracy. Individual character was something people were supposed to have themselves; it was not necessary, therefore, to blatantly advertise it on the facades of buildings. In 1915, Kay Fisker and Aage Rafn were awarded First Prize for the Gudhjem railway stations, published in *Architekten* in 1916. The little timber station at Christianshøj is remarkable. The sun shines through the doors on polished clinkers. There is only one window, a round one, which was certainly inspired by Harsdorff's Pantheon model. In the same year, Kay Fisker designed a summerhouse at Snekkersten with a plan and proportions much like those of the Christianshøj station. These buildings made it clear that classicism was no longer a style but a design sensibility fit for Nordic countries. From 1917 onwards, the Villa Snellman by Gunnar Asplund became the Swedish version of such a yeoman-like Classicism.[26] When in 1919 the Police needed new headquarters away from C F Hansen's Courthouse, Hack Kampmann won the commission. All his best students worked on this project and when Kampmann died in 1919 Aage Rafn became the architect in charge until its completion in 1924. In the Police Headquarters the oculus of the Pantheon is invoked by the circular colonnaded court vaulted by the sky. But the later abuse of classicism discredited the image of this architecture for many years.

MOSQUE IN THE PARTHENON (C. CHAS. GLEYRE, 1834)

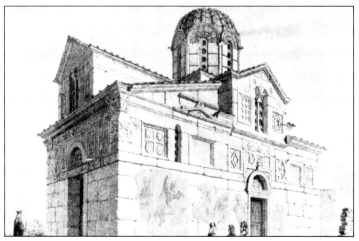

GORGOEPIKOOS, ATHENS (J GAILHABAUD, *MONUMENTS ANCIENS ET MODERNES*, 1850)

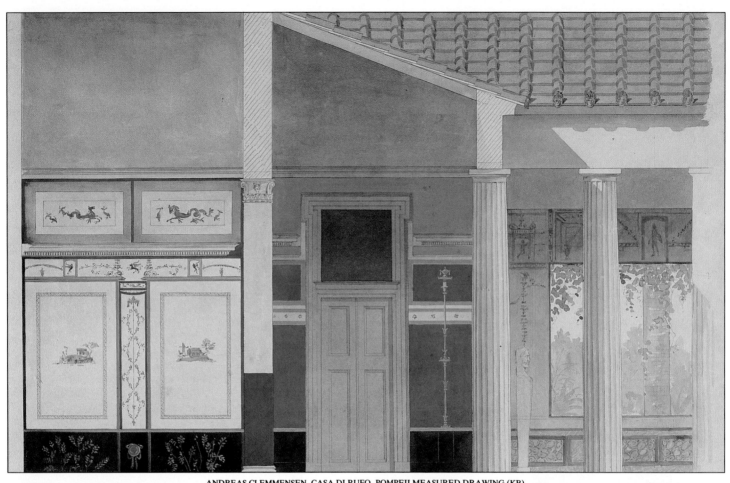

ANDREAS CLEMMENSEN, CASA DI RUFO, POMPEII MEASURED DRAWING (KB)

K FISKER, SUMMER HOUSE IN SNEKKERSTEN, DENMARK, 1916 (PHOTO L B JØRGENSEN)

CARL PETERSEN, FAABORG MUSEUM, 1912-15 (PHOTO L B JØRGENSEN)

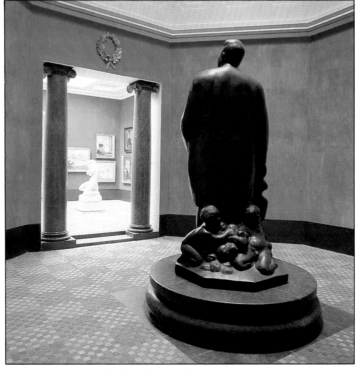

CARL PETERSEN, FAABORG MUSEUM, 1912-15, TWO VIEWS OF THE OCTAGON ROOM (PHOTO L B JØRGENSEN)

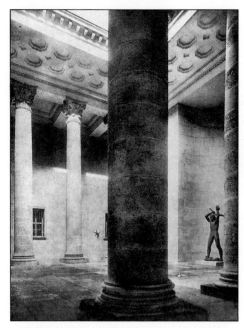

POLICE HEADQUARTERS, RECTANGULAR COURT

K FISKER & A RAFN, CHRISTIANSHØJ STATION, 1915 (KB)

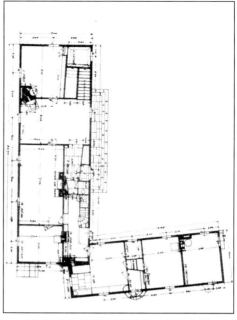

G ASPLUND, VILLA SNELLMAN, 1917-18 (SRM)

Today, classical architecture is once again being re-evaluated: it is no longer seen as a symbol of oppression but as an uplifting promise of civic values. The perception of an architectural language will always be coloured by social conditions, personal experiences, political ideas or even an event that happens to be associated with a building. A positive or negative valuation of architecture is always emotionally conditioned. The gardener's house at Porta Pinciana in the Borghese Gardens in Rome made people shudder for they believed that the unhappy Beatrice Cenci had hidden there. A later generation loved and copied it because they imagined Raphael living happily with his Fornarina in this paradisical hiding place.[27]

Today, industrialised society has once again felt the need for true civic values. When in 1910 Kay Fisker and Aage Rafn measured an eighteenth-century residence in Copenhagen, they were impressed not by its style but by its refined sense of proportion and the rationality of its design. These became the principles for the evolution of tradition so that classicism could once again be understood not as a mere style but as a way of thinking.[28] In a democratic state it is appropriate, as in Athens, that a library, a school, a stadium or a museum should be prominent buildings of outstanding quality. Today we must look back again to the sources of our culture so that we may re-interpret the principles which have guided for ages the development of our cities.

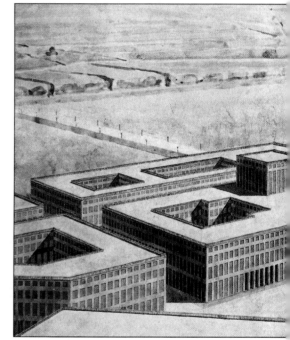

IVAR BENTSEN, OPERA AND PHILHARMONIC

Notes
1 F Meldahl and P Johansen, *Kunstakademiets Historie, 1700-1904*, Copenhagen, 1904.
2 Frederik Weilbach, *Architekten C F Harsdorff*, Copenhagen, 1928.
3 J M Thiele, *Thorvaldsens Biografi*, Vol III, Copenhagen, 1854, pp 45-46, 62, 165.
4 Knud Voss, *Arkitekten Nicolai Eigtved, 1701-1754*, Copenhagen, 1971, pp 366-82.
5 F Weilbach, *op cit*, p 254.
6 F Weilbach, *op cit*, pp 250-57.
7 *Goethes Werke* (Hamburg ed), 1961, Vol XI, pp 219-20.

CARL PETERSEN, FAABORG MUSEUM,

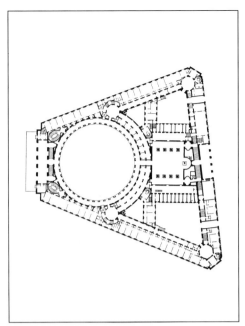

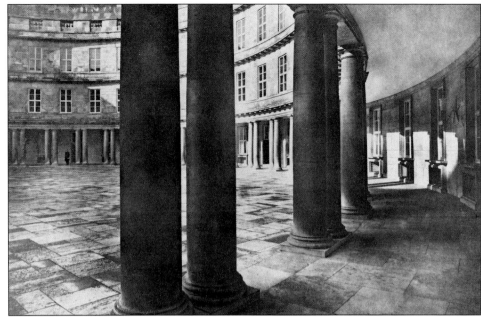

HACK KAMPMANN & A RAFN, POLICE HEADQUARTERS, COPENHAGEN, 1919-24, PLAN AND VIEW OF COURTYARD

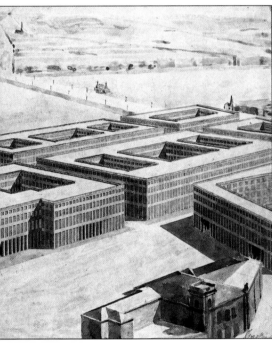

HALL, COPENHAGEN, PROJECT, 1918 (KB)

8 E Kaufmann, *Architecture in the Age of Reason*, 1966, pp 183, 206. Paul Venable Turner, 'Joseph-Jacques Ramée's First Career', *The Art Bulletin*, 1985, Vol LXVII, 2, pp 259-77.
9 L Balslev Jørgensen, *Danmarks arkitektur, Enfamiliehuset*, Copenhagen, 1979, pp 28-31.
10 Claus Smidt, 'Vor Frue Kirkes omgivelser', *Architectura (DK)*, 3, 1981, pp 36-60.
11 Hakon Lund, *Christiansborg Slot. Det andet Christiansborg*, Copenhagen, 1975, pp 1-104.
12 Melchior Missirini, *Della vita di Antonio Canova*, Milan, 1825, p 373.
13 J M Thiele, *op cit*, Vol II, p 293.
14 Thorvaldsen's Museum, archives.
15 Constantin Hansen, *De skjønne Kunsters Eenhed*, Nordisk Universitets-Tidskrift, Vol IX, 1863.
16 L Balslev Jørgensen, 'Thorvaldsen's Museum: a national monument', *Apollo*, Sept 1972, pp 24-31. Also, 'A Display of Life and Art, 1848-1984', *The International Journal of Museum Management and Curatorship*, 1984, 3, pp 237-50. Cf also, Henrik Bramsen, *Gottlieb Bindesbøll liv og arbejder*, Copenhagen, 1959.
17 Leo von Klenze, *Sammlung Architektonischer Entwürfe*, Heft I, Munich 1830, pp 2-7. Cf also, David van Zanten, *The Architectural Polychromy of the 1830s*, London, 1977, pp 150-212.
18 *H C Andersens Dagbøger*, Vol II, Copenhagen, 1973, pp 154-87.
19 Chr Bruun and L P Fenger, *Thorvaldsens Museums Historie*, Copenhagen, 1892.
20 J M Thiele, *op cit*, Vol IV, p 247.
21 M Missirini, *op cit*, p 403.
22 Text of the subscription list, Jan 11, 1837, from the Thorvaldsen Museum archives.
23 George Niemann and Ferd V Feldegg, *Theophilos Hansen und seine Werke*, Vienna, 1893, pp 53-56. Theophilos Hansen, *Erläuterungen zu der Skizze für das in Wien neu auszuführende Österreichische Parlaments-gebäude*, Vienna, 1874, pp 8-9. Knud Millech, *Christiansborg Slot, Det tredie Christiansborg*, Copenhagen, 1975, pp 203-24.
24 Carl Petersen, *Manus*, Kunstakademiets Bibl, Farver. Also, Carl Petersen, *Om Sorø*, Soranerbladet, 7, p 55.
25 *Nordic Classicism 1910-1930*, Helsinki, 1982, pp 29-48.
26 *ibid*, p 122.
27 L Balslev Jørgensen, 'Rafaels hus og den danske hygge', in *Tilegnet Mogens Koch*, Copenhagen, 1968, pp 49-58.
28 Demetri Porphyrios (ed), 'Classicism is not a Style', *Architectural Design* Profile 41, London, 1982. Also Martin Steinmann (ed), 'Kay Fisker 1893-1965', *Archithese*, 4, 1985, Zürich.

FUNEN, 1912 (*ARCHITEKTEN*, 1924)

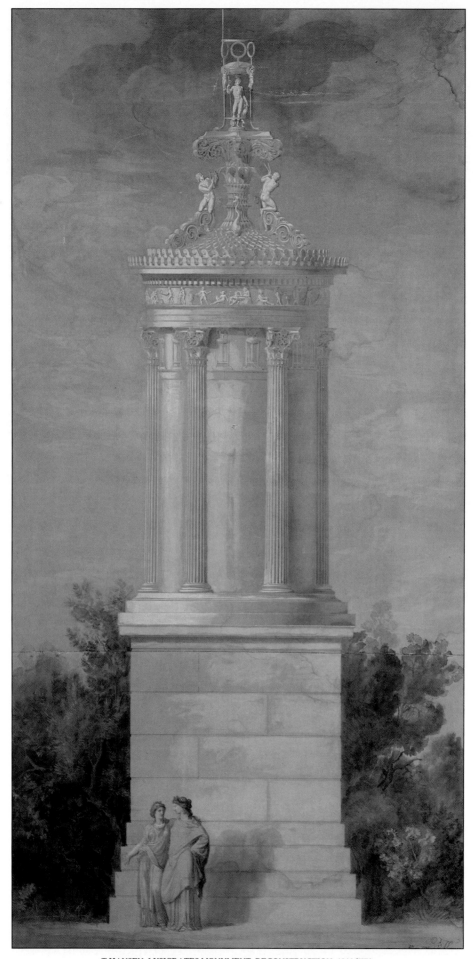

T HANSEN, LYSICRATES MONUMENT, RECONSTRUCTION, 1846 (KB)

DANISH CLASSICISM IN ATHENS

Ida Haugsted

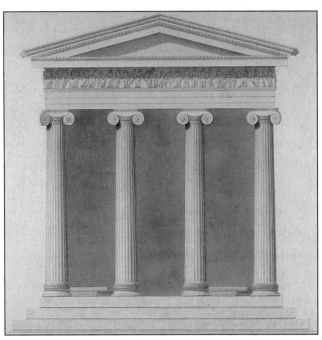

CHRISTIAN HANSEN, TEMPLE OF NIKE, RECONSTRUCTION, 1839 (KB)

ERY FEW PEOPLE BEFORE THE END OF THE eighteenth century travelled in Greece and Europeans knew Greek antiquity only from the ancient literature and art found in the Roman and Greek sites of Italy. When in the middle of the eighteenth century, however, Europeans discovered sites such as Paestum, with its magnificent Doric temples, the Roman Vesuvian sites at the gulf of Naples, and the Etruscan graves of Toscana, the interest in Greek culture took a new direction. The art historian Johann Joachim Winckelmann (1717-68), in his famous book *Geschichte der Kunst des Altertums*, 1764, assigned to the art of Egypt, Greece and Rome a new mythical aura. Similarly, *The Antiquities of Athens*, 1762-94, by Stuart and Revett, and Le Roy's *Ruines des Plus Beaux Monuments de la Grèce*, 1758, presented to European architects hitherto unknown drawings and descriptions. Le Roy's book was often inaccurate but Stuart and Revett's measured drawings were to serve as the only accurate record of the monuments for the next hundred years.

Around 1800 English and French travellers started visiting Greece and their descriptions and drawings of the countryside, the people, the ruins and monuments appeared in the European book market. What fascinated foreigners was the juxtaposition between classical Greece, as seen in the ruined monuments, and the oriental customs of its contemporary people – Greece had been occupied by the Turks since the fifteenth century and was freed only following the War of Independence, 1821-30. European Gothic, Renaissance and Neoclassical cultures, therefore, had played no role in formulating early nineteenth-century Greek culture.[1]

Danish Architects in Greece

Among the early travellers who went to Greece were a few Danes. Between 1810 and 1813 the archaeologist Peter Oluf Brøndsted (1780-1842) travelled with a company comprising the architects C R Cockerell and Karl Haller von Hallerstein, the artists Jacob Linkh and Otto Magnus von Stackelberg, and the Danish linguist Georg Köes.[2] Brøndsted's travels and his interest not only in Greek antiquity but also in contemporary Greek culture, customs and landscape were of immense importance in awakening interest in Greece among Danish artists, architects and archaeologists. He published his impressions in *Voyages et Recherches dans la Grèce*, 1826-30, which also appeared in a German edition. Brøndsted was a man of influence in cultural circles in Denmark, Rome, Paris and London. Between 1819 and 1830 he was Danish cultural attaché in Rome, a position highly respected by those frequenting the artistic circle around the Danish sculptor Bertel Thorvaldsen (1770-1844). Thorvaldsen and Brøndsted were close friends and were both deeply interested in Greek antiquity. It was circles such as theirs which cultivated the desire in artists and architects to visit Greece.

The very first Danish architect to visit Greece was Jørgen Hansen Koch (1787-1860). Encouraged by the German architects studying in Rome, Koch went to Athens in 1818-19 with his colleagues Josef Thürmer (1789-1833), Franz Heger (1792-1836) and Heinrich Hübsch (1795-1863). Following Stuart and Revett, they were among the European pioneers who measured and described the classical monuments of Athens. Their books on Athens appeared in the 1820s.[3] Koch and Heger also planned a work on measured drawings of the Parthenon and Theseion but never succeeded in raising the money necessary for such an edition.[4]

Following the War of Independence, there were many Europeans who wanted to visit Greece, but only a few realised their dream. Among the European architects to arrive in the country during the first decades of the new kingdom were three Danes: Christian Hansen, his younger brother Theophilos, and Gottlieb Bindesbøll. These three, along with several other Danes, were part of a small group of Scandinavian expatriates in Athens in the 1830s.

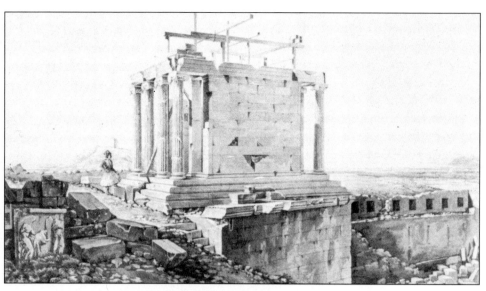

G F HETSCH, PANTHEON CAPITAL (KB)

TEMPLE OF NIKE, RESTORATION (ROSS & SCHAUBERT, 1839)

The Danish painter Martinus Rørbye (1803-48) travelled with Bindesbøll in Greece in 1835-36.[5] But more importantly, this group included the well-known archaeologist Ludwig Ross (1806-59) from Kiel, in the Royal Danish Duchy of Schleswig-Holstein. Ross had arrived in Athens in 1832. Between 1834 and 1836 he was Chief Conservator of Greek antiquities and then from 1837 until his departure from Greece in 1845 he was professor of archaeology at the University of Athens. In the 1830s Ross was a very influential person, leading the restoration work on the Acropolis and publishing a number of books on Greek culture and archaeology.[6]

The Danish architects visiting Greece had studied classicism at the Academy of Fine Arts in Copenhagen. The leading professors there were the classicists C F Harsdorff (1735-99), C F Hansen (1756-1845) and Gustav Friedrich Hetsch (1788-1864). It was Hetsch, professor at the Academy of Fine Arts since 1815, who had the greatest influence on the Hansen brothers and the other artists of their generation. Hetsch taught his students the principles of the classical orders, stressed the importance of proportion and initiated a taste for the architecture of classical antiquity. The Danish architects who worked in Greece during the reign of King Otto (1831-63) were all students of G F Hetsch and strongly influenced by his classical ideals.

Christian Hansen in Athens
Christian Hansen (1803-83) was born in Copenhagen and was a student of G F Hetsch at the Academy of Fine Arts from 1816. In 1829, Hansen was awarded the Academy's Gold Medal and then worked at the office of the architect C F Hansen. In 1851, he won a travelling scholarship which enabled him to visit Rome. He travelled via Berlin and Munich where he admired the new buildings of Karl Friedrich Schinkel and Leo von Klenze, and on Christmas Eve, 1831, he arrived in Rome. He described this journey in his diary of 1831 and in various letters to his family.[7]

In Rome Hansen met the Danish and other European artists who frequented the studio of Bertel Thorvaldsen and gathered at the Café Gréco in Via Condotti. Then thirty years old, he stayed in Rome for two years to study the monuments of Roman antiquity and the rich collections of the Vatican Museum. While in Italy he felt the desire to go to Greece, recently liberated from the Turkish occupation. First, however, he visited Southern Italy, Naples, Pompeii, Paestum and the Greek sites of Sicily.

What motivated Christian Hansen to go to Greece was a yearning to find the true art at its sources. While in Sicily he was no doubt fascinated by the polychromy of Greek architecture. Once in Athens he wrote to the Academy of Fine Arts in Copenhagen about his studies of the polychromy of the cornice of the Parthenon,

saying: '. . . *I have not yet discovered whether the temples generally were painted as somebody believes . . .*' (November 11, 1833). Hansen's remark refers to the vehement discussions that followed J I Hittorff's theory of polychromy in the 1820s. Hittorff, having studied the polychromy of Sicilian temples, had come to the conclusion that the ancients painted their stone temples in bright colours. Similar observations had already been reported by the Brøndsted expedition, and in 1832 a friend of Hittorff, the architect Gottfried Semper from Altona, visited Athens with the express intention of studying the polychromy of the architecture.[8]

Christian Hansen had planned to stay in Athens for a couple of months and then return to Rome. As it turned out he lived and worked in Greece for the next seventeen years.

When Christian Hansen arrived in August 1833 he was overwhelmed by the landscape and the people. In a letter dated September 5, 1833, he wrote: '. . . *Greece is very beautiful. The numerous shapes of the mountains and the beautiful colours of nature, as well as the friendly people and their interesting costumes . . . seemed to me as a totally different world. Pettrich[9] and I were sometimes in ecstasies of joy. But the country is very difficult to traverse, because there are no roads, and also one gets depressed by the completely ruined villages . . . and the completely wild and uncultivated land. But for the artist this is an instructive place . . .*' (The Royal Library Add 257, 2°). On reaching Athens, Hansen was shocked by the streets and houses devastated by the war. At that time the city had only about six thousand inhabitants.

The year after Hansen's arrival, Athens became the capital of Greece. Architects were now needed to reconstruct the city and in 1834 Christian Hansen was appointed architect to the Greek Royal Court.

The story of Christian Hansen's work in Athens is fascinating. He was one of the few Europeans who faced the challenge of building up the future metropolis, restoring the ancient monuments, constructing houses, churches, harbours, etc. In Athens, Hansen met the Chief Conservator Ludwig Ross who, as a professional archaeologist, taught him many important things about ancient Greek history, art and archaeology. Together they travelled in the Peloponnese, the Greek islands and elsewhere, and collaborated on many restorations. Christian Hansen also became a close friend of the German architect Eduard Schaubert (1804-60) from Wroclau. Schaubert had come to Greece in 1831 with the Greek architect Stamatios Kleanthis after studying at the school of Schinkel in Berlin.

The Restorations
In August 1834, a proposal by Leo von Klenze and Ludwig Ross to

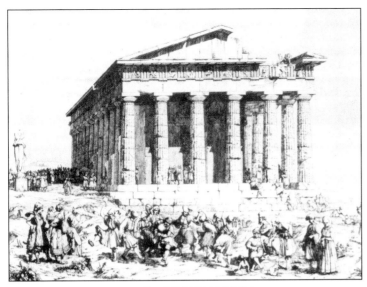

THESEION, 5TH CENTURY BC (GL)

KLEANTHIS & SCHAUBERT, FIRST PLAN OF ATHENS, 1834 (AE)

secure the future of the Acropolis was agreed to by the government. The restorations began in January 1835 and lasted until 1837. Ross was assisted by Christian Hansen, Eduard Schaubert, the French architect E Laurent, and the Greek archaeologist Pittakis. This was the first large-scale restoration of a classical monument to take place in Greece.[10]

During these years they cleared the bastion in front of the Propylaea and searched for the road that led up to the Acropolis. It was then that they found the remnants of the classical Temple of Nike Apteros built in 425 BC and probably demolished in 1687 by the Venetians when they attacked Athens. The Ross team restored the temple. This unique opportunity to work on a classical temple on the Acropolis itself gave Hansen an invaluable experience. He could now study the technical details of classical architecture, something which proved of immense importance to his architectural career in Athens, Trieste and Copenhagen.

The team restored the columns and floor of the Parthenon and, in the process of this work, found sculptures and architectural fragments of the temple as well as the foundations of the older Parthenon. At the same time Hansen and Schaubert studied the polychromy of the Theseion. The results of the restoration work on the Acropolis were published in the *Dansk Kunstblad* and Tübigen's *Kunstblatt*. A book on the restoration of the Temple of Nike was published by the Ross team in 1839. Shortly after, in 1851, F C Penrose published *An Investigation of the Principles of Athenian Architecture* in London. This was the first publication to amend Stuart and Revett's measured drawings. A new chapter in the history of Greek classical architecture had been opened.[11]

Bindesbøll visits Athens
Among the Danish travellers who visited Athens during the Othonian period was the architect Gottlieb Bindesbøll (1800-56), who arrived in October 1835 with the Danish painter Martinus Rørbye. They were both on scholarships from the Academy of Fine Arts in Copenhagen and after meeting in Naples they travelled to Greece, excited by the news of the ongoing restorations of the Acropolis. From the start Bindesbøll had planned to travel to Athens, but the Academy of Fine Arts recommended that he took the classical tour via Berlin, Munich and Rome. In Berlin, at the end of July 1834, Bindesbøll met the famous Danish poet Hans Christian Andersen – who was on his way back to Denmark from Italy – and asked him to carry a letter to the architect Jørgen Hansen Koch which enclosed a plan and description of the project for a royal castle on the Acropolis by Karl Friedrich Schinkel. At that time in Athens there were vehement discussions concerning Schinkel's fantasy. Ross and Klenze criticised and opposed his whimsical proposals and argued

for the preservation and restoration of the classical monuments on the Acropolis.

Bindesbøll had known Christian Hansen as a fellow student at the Academy of Fine Arts and had worked between 1823 and 1833 with the architect Jørgen Hansen Koch. Bindesbøll and the painter Rørbye stayed in Greece nearly half a year, during which they also found time to visit Smyrna and Istanbul.[12]

Bindesbøll lived in Rome both before and after his visit to Greece and the inspiration he derived from his stay in Athens was of the greatest importance to his work. He made about eighty measured drawings and sketches in Greece, mostly of the Acropolis, and witnessed the restoration of the Temple of Nike between November 1835 and the following spring. He measured the Theseion and painted aquarelles of the classical polychrome fragments of temples discovered around the foundations of the Parthenon. Bindesbøll wrote to his brother from Greece '. . . *The Acropolis surpasses anything else I know of . . . it is the cradle of civilisation . . .*' and exclaimed that the colours of antique architecture were '. . . *very thick and brilliant as a peacock . . .*'[13] When Bindesbøll returned to Rome in the summer of 1836, he worked on a project for a museum that was to house the sculptures of Bertel Thorvaldsen in Copenhagen and undertook a large number of other projects in close collaboration with Thorvaldsen himself. These projects, as well as the executed buildings, are heavily indebted to the Athenian monuments and to the polychromy of classical architecture he had experienced first hand in Pompeii, Sicily and Athens.[14]

Some buildings by Christian Hansen
The first civic building erected by the Greek government in Athens was the Mint. This was designed and built by Christian Hansen between 1835 and 1836 at Klafthmonos Square, where it survived for a hundred years.[15] It was a two-storey building around an open courtyard, built in a Greek vernacular style with some Byzantine details, for instance the *Rundbogen* windows on the ground floor. In an article published in the *Dansk Kunstblad*, 1837, Christian Hansen described his architectural activity during the first four years of his stay in Greece. '. . . *It would be impossible for me to describe the first impression which this completely devasted town [Athens] and its ruins made on me on my arrival. Only a few of the houses had a roof, and the streets were completely unrecognisable since everything had collapsed in boundless confusion. The surrounding beautiful fields looked as though they had never been cultivated.*

'*But since that time things here have changed considerably; considering the poor circumstances a lot has been built, and Athens, as well as other Greek towns, will become very beautiful as time goes by, if*

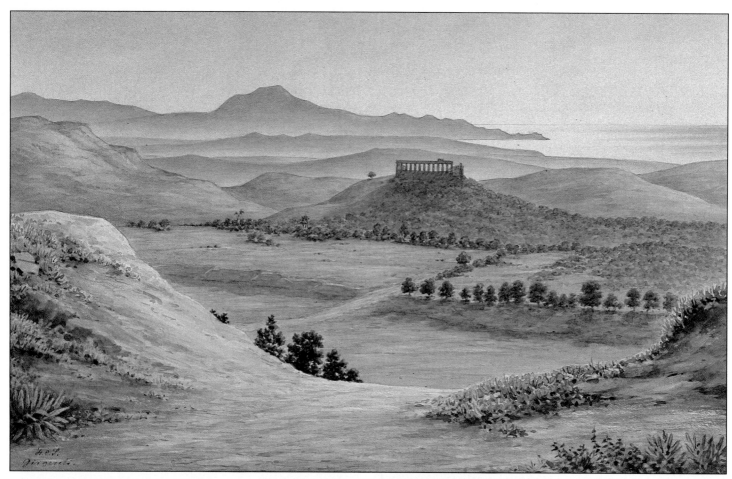

H C STILLING, TEMPLE AT GIRGENTI, SICILY, 1853 (KB)

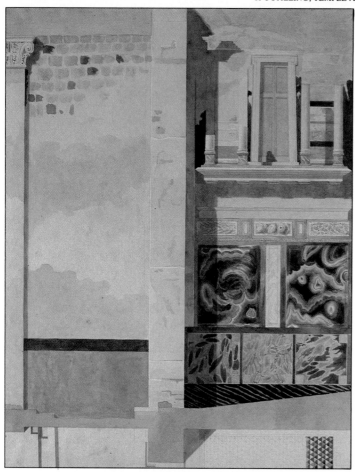

L A WINSTRUP, POMPEII SKETCH, 1849 (KB)

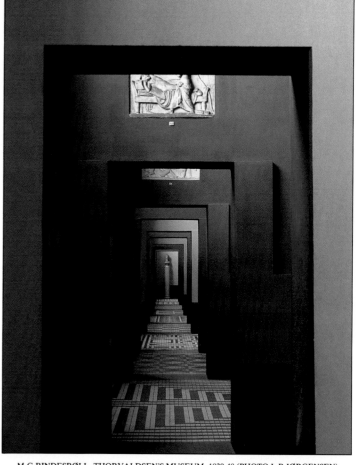

M G BINDESBØLL, THORVALDSEN'S MUSEUM, 1839-48 (PHOTO L B JØRGENSEN)

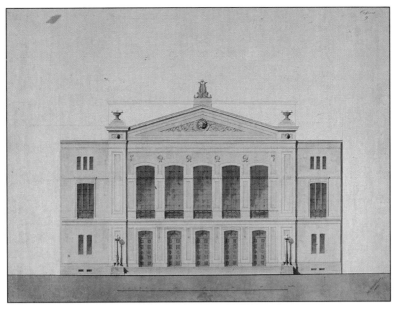

H C STILLING, CASINO-THEATRE, COPENHAGEN, 1846 (KB)

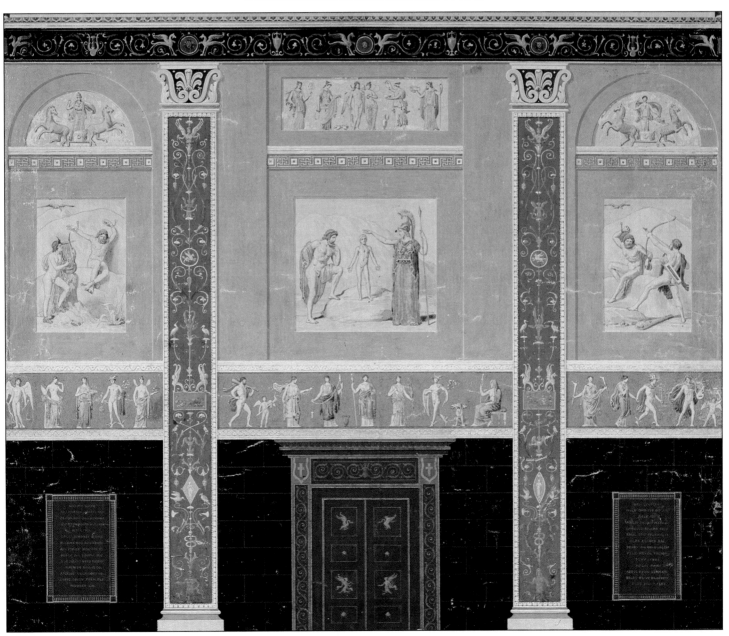

COPENHAGEN UNIVERSITY, VESTIBULE, DECORATION BY CONSTANTIN HANSEN & G HILKER, 1839-40 (KB)

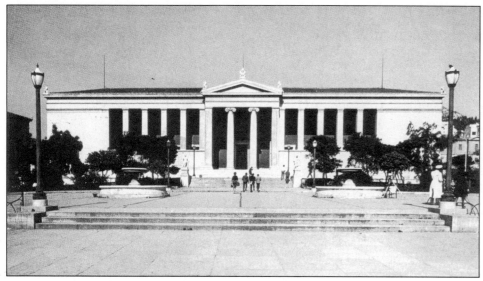

CHRISTIAN HANSEN, UNIVERSITY, ATHENS, 1839-89 (NA)

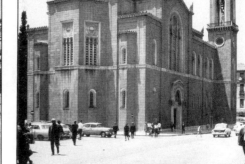

E SCHAUBERT, CATHEDRAL, ATHENS, 1839-62 (NA)

reconstructed according to appropriate plans. During most of my stay in Greece my employment has not permitted me to plan any journey of importance. Therefore, I have had only the opportunity of taking smaller excursions. The Mint which I built was completed some time ago and . . . at the moment they strike a great quantity of copper coins there . . .

'I have also built two private houses. In addition I have converted some churches into courtrooms and a Turkish school into a prison, and have practically completed a big building with shops. Several works have been carried out according to my drawings. Moreover I have executed a lot of drawings, the most important of which are a plan for the city of Corinth, projects for several theatres, a church in Piraeus, a meat-market in Athens, a prison, a Protestant church, a bath at Thermia, a lighthouse in Aegina and others . . . In addition, I have also been employed at the excavations on the Acropolis . . .'[16]

Christian Hansen also designed the Catholic church of St Paul in Piraeus. Though not built until 1836, it features on a plan drawn up two years previously by Kleanthis and Schaubert, and later modified by Leo von Klenze. As this plan (of which a copy has recently been found), as well as another published by F Aldenhofen in 1837, featured the Catholic church, we can assume that it must have formed part of this very early city plan for Piraeus. The church of St Paul was built in the classical style, with its facade designed as a large portico with four engaged columns, crowned by a pediment and the whole dominated by two square flanking towers.

Only three years later Christian Hansen's project for a new university building was approved by the King and the foundation stone was laid on June 1, 1839. The initiative to found a university was taken by Constantine Sina and comprised part of the educational reforms undertaken by the newborn nation. With the University of Athens, Christian Hansen proved himself to be a seminal architect of the nineteenth century.[18]

The siting of the university in the city of Athens was of great importance. The city architect F Stauffert wrote in *Ephemeriden*, 1844, that though the university was placed near the centre of the town amidst houses it was possible when standing on its marble staircase to see the monuments of classical antiquity all around. Ahead one could see the Acropolis framed by the hills of Areopagos and Pnyx where Demosthenes taught the free Greek citizens the art of discursive speech. Towards the southwest was the glittering sea and the island of Aegina, and towards the west the island of Salamis. On the right lay the Academy where Plato had his school.

In designing and executing the university, Christian Hansen used his newly acquired experience from the restorations on the Acropolis. The university became for him a case study where he could now apply the proportions and polychromatic treatment of the classical

monuments. Many architectural details of Hansen's university are indebted to the north portico of the Erechtheion, the Propylaea and the Temple of Nike.

Theophilos Hansen arrives in Athens

While Christian Hansen was busy with the project for the university his brother Theophilos Hansen (1813-91) joined him from Denmark, coming to Greece in October 1838. Theophilos was then only twenty-three years old and had just graduated from the Academy of Fine Arts where he was a student of Professor Hetsch. Before he left for Greece, he had worked on the restoration of the cathedral of Ribe in Jutland.[19] He then travelled through Germany to study the crafts of artisans. Accompanied by the Danish architect Laurits Albert Winstrup (1815-89), Theophilos Hansen visited Meisen, Prague, Nuremberg and Munich. Instead of returning to Copenhagen, he continued to Athens via Trieste, parting with Winstrup, who then went back to Copenhagen, but in 1850 spent a year in Athens.[20]

Once in Athens Theophilos Hansen was immediately accepted in the architectural circles and he started teaching with his brother at Zentners Technical School until 1843. Here they taught craftsmen building methods and technique. Theophilos Hansen stayed in Greece until March 1846, when he left to join the Austrian architect Ludwig Förster, who also edited the famous periodical *Allgemeine Bauzeitung*.

Initially, Theophilos Hansen helped his brother with the project for the university. Then followed the small chapel of Hagios Lukas at Neon Iraklion, 1839-41.[21] But his first significant commission was the private residence of the wealthy Greek merchant Antonios Demetriou. The house was built in Syntagma Square between 1842 and 1843 and has since 1862 served as the Hotel Grande Bretagne. It was rebuilt in 1928 and completely altered in 1958. In a letter to G F Hetsch, Theophilos Hansen wrote that he had selected a simple and unpretentious style where the decoration consisted of cast iron railings in front of the windows and that this element, which he had borrowed from Schinkel, was especially suitable for the South.[22] Theophilos Hansen presented the plans to King Otto for approval since the monarch required that all houses surrounding his castle should be of the highest architectural merit and act as paradigms for the rebuilding of Athens. The facade of the Demetriou house was conceived as a palace front with arcades and a loggia and with balconies supported by finely carved stone lion consoles.

It was his design for the Observatory of Athens, erected on the Hill of the Nymphs, which launched the architectural career of Theophilos Hansen. He secured this commission with the help of Schaubert, who in the meantime had become a close friend of his

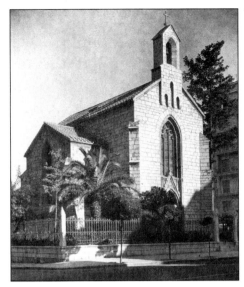

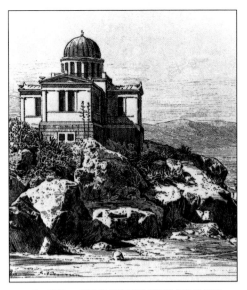

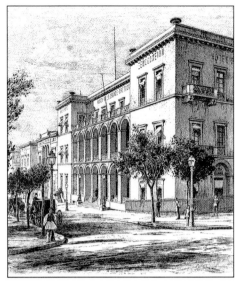

CHRISTIAN HANSEN, ANGLICAN CHURCH, ATHENS, 1839-41 (NA) T HANSEN, ATHENS OBSERVATORY, 1842-46 (TH) T HANSEN, DEMETRIOU HOUSE, ATHENS, 1842-43 (TH)

brother. Schaubert himself had drawn up plans for the new observatory but his cruciform plan and neo-Byzantine style was not to the King's taste. Schaubert then recommended Theophilos Hansen, for he was impressed by the young man's architectural talent. King Otto approved Hansen's project and the new observatory was built between 1842 and 1843.[23] Prince Friedrich Wilhelm of Hessen-Kassel was present at the foundation ceremony '. . . *together with the King and all the ministers*', wrote Christian Hansen in a letter to his mother.[24] The building, which still stands today, was erected exactly on the meridian and the centre crowned by a cupola. It is finished in marble render and decorated with polychromatic ornament both internally and externally.

The Byzantine, Turkish and Gothic Traditions
The European architects who came to Greece were fascinated by the discovery of the tiny Byzantine churches. In the region of Athens there were more than 125 Byzantine churches and monasteries built between the ninth and twelfth centuries. Today only twenty or so are still standing.[25] From various drawings and letters we know that architects were studying the style of these small churches eagerly and that they were fascinated by their materials, details, plans and proportions. Bindesbøll, for instance, made measured drawings of some of the Byzantine churches. Likewise, there are many sketches and details of Byzantine buildings in Christian Hansen's sketchbooks from the 1830s. The Greek Byzantine style, however, was practically unknown outside Greece until the first publications depicting it appeared in Förster's periodical *Allgemeine Bauzeitung* between 1850 and 1853. While both Schaubert and the Hansen brothers tried to use the tradition of the Byzantine style as a possible alternative to classicism, they did not meet with much luck. The Byzantine style never became popular except in the architecture of churches.

In 1840, Christian and Theophilos Hansen together with Eduard Schaubert drew up plans for the new Athens Cathedral which utilised many Byzantine stylistic elements. After the Greek revolution of 1843 the project was changed and other architects were involved. The cathedral standing today on Hermes Street was completed in 1862. Building materials from about seventy small, ruined Byzantine churches were used in its construction.

Another project which was executed in the neo-Byzantine style was the Eye Clinic, which still stands in Panepistimiou Street next to the Academy. This was built as a one-storey structure between 1847 and 1852, just after Theophilos Hansen had left Athens. The walls have effects of horizontal stripes in red brick, *Rundbogen* windows, and other stylistic traces of Byzantine architecture. The Eye Clinic was altered by the Greek architect Metaxas in 1869 with the

addition of an upper storey.[26]

The Anglican church of St Paul by Christian Hansen must be mentioned as an example of the stylistic experiments of the period. It was built between 1840 and 1841 in Philhellenon Street for the English Protestants in Athens. Christian Hansen used the Gothic style for the first time in Greece and combined it with a Byzantine-inspired bell-tower. This church was surely an attempt to combine European and Greek architectural traditions.

In 1838, Christian Hansen drew up plans for a lighthouse in Patras. The aquarelle of it in the Academy of Fine Arts in Copenhagen shows that in this case he was clearly inspired by Turkish architecture in Greece and used the minaret as a model. This project was never carried out.[27] We learn from Hansen's sketchbooks that he visited Chalkis in Euboia in May 1838, where he studied the Turkish architecture of houses, mosques, minarets, wells, etc.[28]

The New Era
The 1840s in Greece were years of confusion and political chaos. On September 15th, 1843, a revolt against the monarchy broke out. King Otto had to sign a document which considerably weakened his powers and had serious consequences for all foreigners who worked and lived in Greece. The finances of the country were in an embarrassing state and several officers and civilians were discharged from public service. Many foreigners were forced to leave immediately or within a few years. This was the case with Eduard Schaubert, who lost his job. In view of these political developments Ludwig Ross and Theophilos Hansen decided to leave Greece. Only Christian Hansen remained, leaving his post much later in 1850.

In a letter to Professor G F Hetsch, written in August 1843, Theophilos Hansen gave a description of these events. '. . . *I can assure you, dear professor, that the hatred towards foreigners has now reached its peak, so that it is nearly impossible to stay here any longer. . .Our good friend Schaubert is among those who have been dismissed in the most outrageous manner and as his business has been taken over by my brother . . . and as our projects will not be finished for two or three months, we have decided to stay for a short time . . .*'[29] Presumably the unfinished projects Theophilos Hansen refers to must have been the university, the observatory, the Demetriou House and the Metropolis. The political climate of the period that followed made it difficult to complete unfinished projects and a number of them were abandoned.

Theophilos Hansen leaves Athens
In 1846 Theophilos Hansen painted a large aquarelle of the Lysicrates monument (335 BC), which he had studied for three months

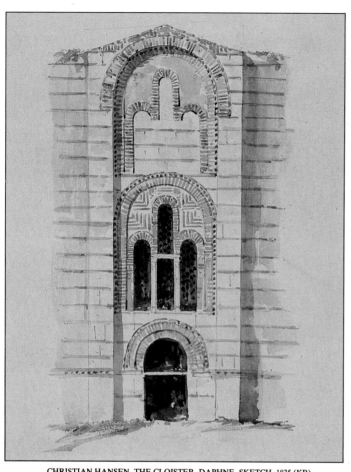

CHRISTIAN HANSEN, THE CLOISTER, DAPHNE. SKETCH, 1835 (KB)

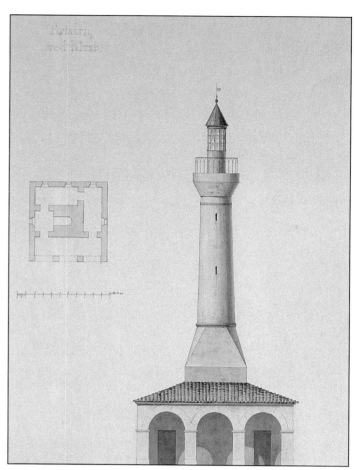

CHRISTIAN HANSEN, LIGHTHOUSE, PATRAS, 1853-57 (KB)

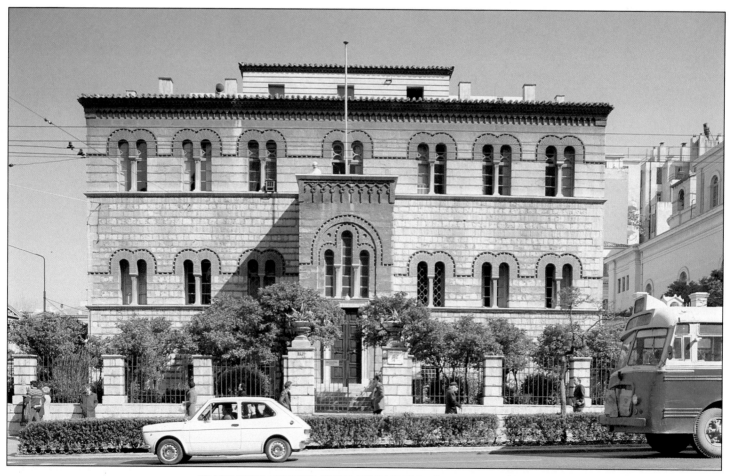

CH & T HANSEN, EYE CLINIC, ATHENS, 1850-54 (ALTERED) (PHOTO D PORPHYRIOS)

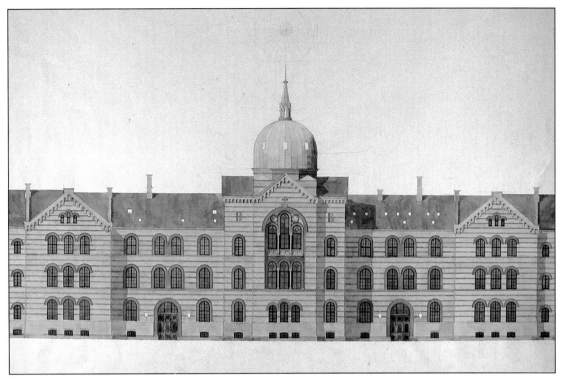

CHRISTIAN HANSEN, MUNICIPAL HOSPITAL, COPENHAGEN, 1859-63. MEASURED DRAWING, 1949 (KB)

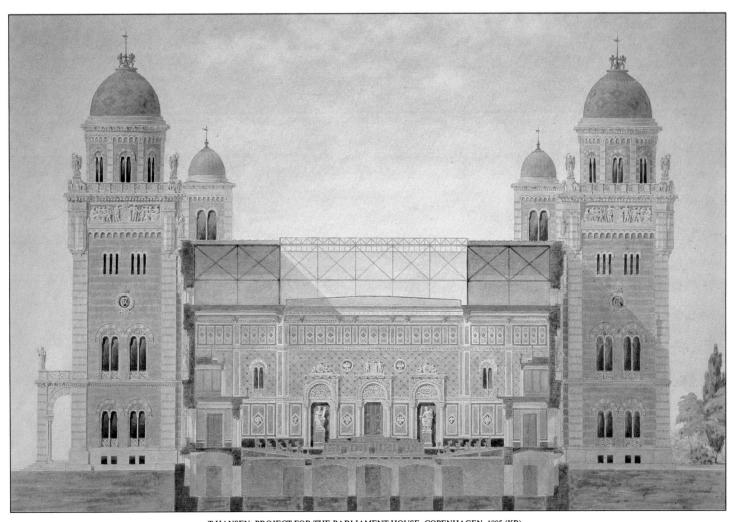

T HANSEN, PROJECT FOR THE PARLIAMENT HOUSE, COPENHAGEN, 1885 (KB)

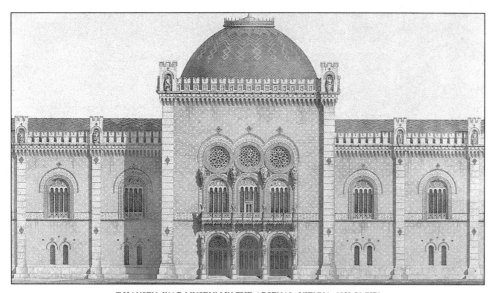

T HANSEN, WAR MUSEUM IN THE ARSENAL, VIENNA, 1850-56 (KB)

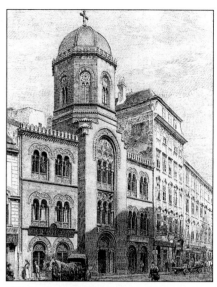

T HANSEN, GREEK CHURCH, VIENNA, 1858 (TH)

in 1845, when it was restored by French archaeologists. It was not the first time that Theophilos Hansen had measured a building of classical antiquity. He had already measured and drawn the Erechtheion and his drawings of it were published in Hoffers' and Tetzas' articles in the *Allgemeine Bauzeitung*, 1851. In fact, Prokesch-Osten, the Austrian ambassador to Athens, had ordered casts of the Erechtheion to be sent to Vienna. Though not archaeologically correct, Theophilos Hansen's reconstruction of the Lysicrates monument attracted the attention of the Austrian architect Ludwig Förster (1797-1863), who asked the young Dane to join him at his office in Vienna. Theophilos Hansen accepted the invitation and on March 16th, 1846, left Athens.

Theophilos Hansen in Vienna

In the course of the next four years Theophilos Hansen built many houses and villas in collaboration with Ludwig Förster.[30] It is difficult to identify Hansen's contribution, but presumably Förster drew the plans whilst Hansen must have been responsible for the decoration and ornament. The work of Theophilos Hansen in the late 1840s and 1850s was marked by his use of Greek Byzantine elements and experiments with bricks both for their textural and polychromatic effect.

Following the revolution of March 1848 a new era began in Vienna. After 1851, when Franz-Josef (1830-1916) introduced an absolute monarchy which was to last for the next fifty years, an explosive activity in building and city planning took place. *Romantischer Historismus* was the dominant stylistic movement of Austrian architecture. In 1849, Theophilos Hansen and Förster collaborated on a competition for the New Arsenal in Vienna. In 1851, however, the friendship between the two architects ceased. Theophilos Hansen opened an office of his own and started working on the Army Museum.[31] The execution of the Army Museum, built between 1849 and 1856, was an important event in Theophilos Hansen's career. Forming part of the Arsenal, it was clearly inspired by Schinkel and Klenze.[32] Hansen described it in the *Allgemeine Bauzeitung*, 1866, as follows: '*With regard to the style of the building, I have used the original Byzantine way of building which one can find in the churches of the Orient because I found this style appropriate to the purpose of building and to the materials here available.*' The exterior is decorated with ornament inspired not only by the Byzantine style, but also by Islamic and medieval architecture. When the building was inaugurated in 1856 it was so much admired by the public that Theophilos Hansen felt he had invented a successful alternative to that of classical antiquity.

During the next years Theophilos Hansen built a series of buildings in the Byzantine style, including the Invaliden Hospital in

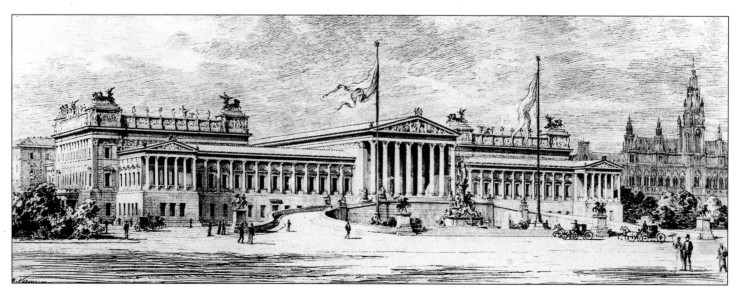

T HANSEN, PARLIAMENT, VIENNA 1874-84 (TH)

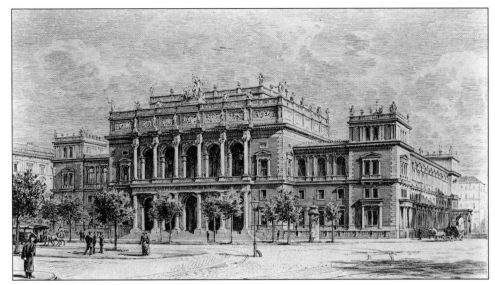

T HANSEN, EXCHANGE, VIENNA, 1877

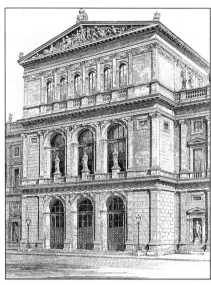

T HANSEN, MUSIKVEREIN, VIENNA, 1864-69 (TH)

Lemberg (1854-59), the Greek Church (1856-58) and the Evangelic chapel in Vienna (1858). In 1859 a new period began with the planning of the Ringstrasse. Theophilos Hansen contributed a number of buildings to this vast project, such as the Rudolfshof, the Evangelic school, the Musikverein, the Epstein and Ephrussi Palaces, the Stock Exchange, and the Academy of Fine Arts; all executed in the 1860s and early 1870s.[33]

The most significant and influential work of Theophilos Hansen in Vienna, however, was the Parliament (1874-83). The building was commissioned by the Austrian ministry and Hansen was honoured to have been asked to design such an important monument.[34] The building exemplifies the ideal of a perfect unity between architecture, sculpture and polychrome ornamentation. 'Architecture on its own . . . ', Hansen wrote, 'is not free, for it must be united with sculpture and painting. And in no other style has this succeeded as perfectly as in the noble simplicity of the Greek style.'[35] As for his decision to design the Parliament in the classical style, Hansen believed that only Greek classical antiquity could express the greatest nobility that befitted such a civic monument.

Following the completion of the Vienna Parliament, Theophilos Hansen was awarded the *doctor honoris causa* at the University of Vienna and in 1888 he received the Gold Medal of the Royal Institute of British Architects.

Christian Hansen in Trieste and Copenhagen

In a letter to Professor Hetsch in February 1850 Christian Hansen deplored the fact that nobody wanted to build in Greece and complained that there were no funds available for the completion of the University of Athens.[36] In July of that year Christian Hansen went to Trieste to design a shipyard for the Austrian Lloyd Steamboat Company and was to work there for the following seven years.

The shipyard was built in a simple *Rundbogenstil* faced with white limestone from the quarries of Pola. Windows and entrances were ornamented with red-coloured brick and all the buildings were covered with slated roofs. This was a true industrial complex from the early days of the steamship era. Parts of it still exist today along Trieste's Passagio di S Andrea.[37]

This was to be Christian Hansen's last work abroad for after twenty-three years as an architect in exile, at the age of fifty-three, he was appointed professor at the Royal Academy of Fine Arts in Copenhagen. In March 1857, he left his lonely position by the Adriatic Sea and went back to his beloved homeland.

During the 1850s and 1860s, while Theophilos Hansen was busy with the Ringstrasse projects, Christian Hansen worked on a number of commissions in Copenhagen. In addition to his professorship at the Royal Academy of Fine Arts, he was Inspector General of the university buildings. Between 1859 and 1861, he built the new

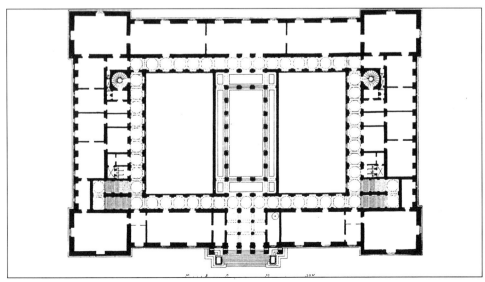

T HANSEN, ACADEMY OF FINE ARTS, VIENNA, 1872-79, PLAN (TH)

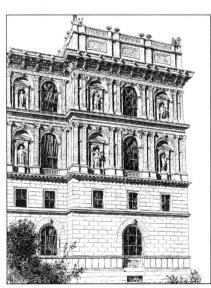

ACADEMY OF FINE ARTS, SIDE WING (TH)

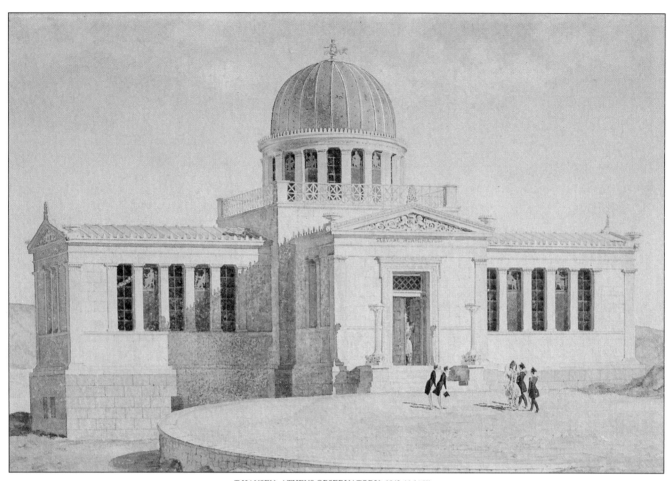

T HANSEN, ATHENS OBSERVATORY, 1842-46 (AK)

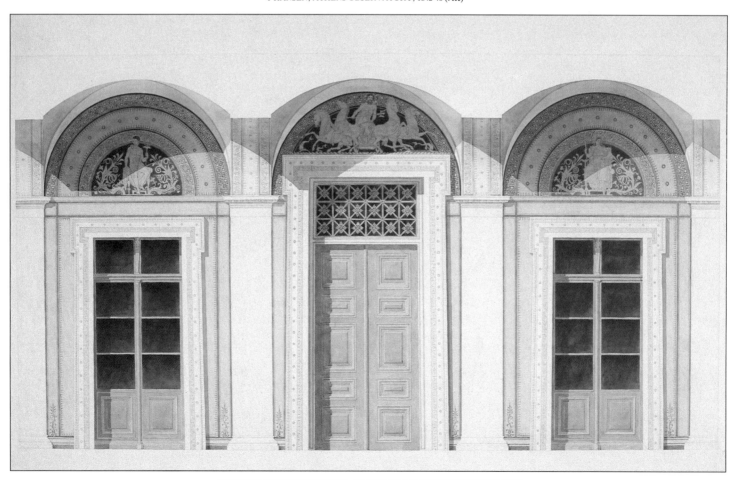

T HANSEN, DEMETRIOU HOUSE, ATHENS, 1842-43, VESTIBULE DETAIL (AK)

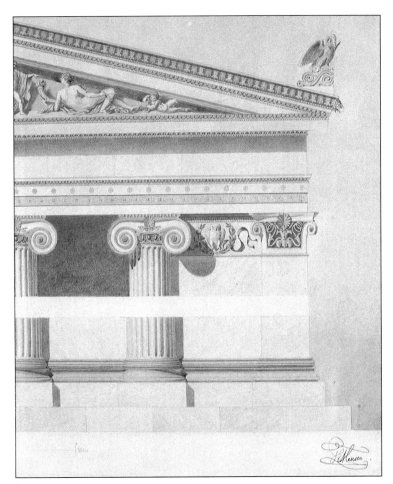

T HANSEN, ATHENS ACADEMY, ELEVATION STUDY (AK)

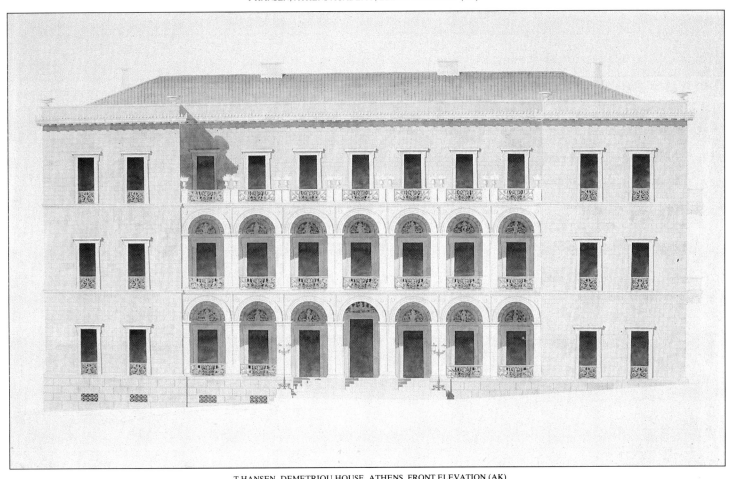

T HANSEN, DEMETRIOU HOUSE, ATHENS, FRONT ELEVATION (AK)

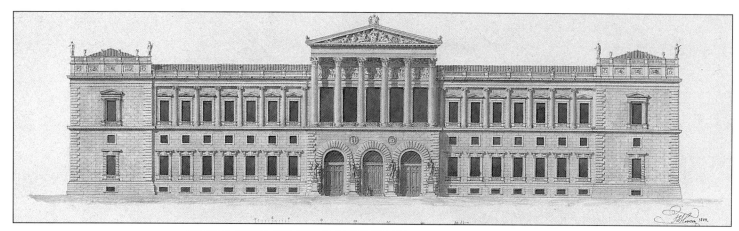

T HANSEN, CHRISTIANSBORG PALACE, COPENHAGEN, RESTORATION PROJECT, 1884 (KB)

University Observatory and Astronomical Institute.[38] At the same time (1859-63), Christian Hansen designed and built the Municipal Hospital at Søerne, Copenhagen. This complex of buildings was built in *Rundbogenstil* with the characteristic facade in yellow and red brick stripes. Hansen's experience with industrial architecture in Trieste was surely of good use to him in this project.

Later works by Christian Hansen in Copenhagen include the Zoological Museum (1863-69), the Hospital of St Joseph (1873-75), the side wings to the Surgical Academy (1867), a Gothic church in Holbaek, a Hospital Chapel in Slagelse (1864-65), and the Zoological Museum in Krystalgade. This museum is the most interesting of his later buildings, with an inventive plan which influenced several zoological museums built in the nineteenth century in Europe.[39]

In 1850 Christian Hansen became a member of the Royal Institute of British Architects, and in 1879 he was awarded the *doctor honoris causa* at the University of Copenhagen.

Theophilos Hansen in Copenhagen

Between 1884 and 1887, Theophilos Hansen was deeply engaged with a project for a parliament and castle to be executed in his native city of Copenhagen at Slotsholmen. The old Christiansborg Palace built by the architect CF Hansen had burned down in 1884 and Theophilos Hansen drew up several projects for its reconstruction. However, he was not given the job.[40] The drawings are now in the Academy of Fine Arts in Copenhagen and his letters and diary in the Royal Library. His first project for a parliament building from 1884 was a symmetrical complex reminiscent of the parliament in Vienna and influenced by Schinkel's 'Schloss Oriana'. Between 1886 and 1887 he made radical changes and prepared a project for a parliament in the Byzantine style with a rational symmetrical plan as in the earlier proposal. The flanking corners were crowned with cupolas and the windows were rendered in the characteristic *Rundbogenstil* he had so often used in Athens and Vienna.[41]

The Athenian Trilogy and Theophilos Hansen's last projects in Athens

The three buildings comprising the 'Athenian Trilogy' in Panepistimiou Street (the University, the National Library and the Academy) were designed and built by the Hansen brothers between 1839 and 1892.

Next to the University begun in 1839 by Christian Hansen, Theophilos Hansen built the Academy. The foundation stone was laid in 1859 and for the next twenty years the work was supervised by Ernst Ziller (1837-1923). Construction was hindered again and again by political and economic problems and the Academy was not completed until 1887.[42] It was built in the Ionic style and the numerous polychrome details decorating the exterior have recently been restored. The plan of the Academy is clearly inspired by the arrangement of the Propylaea on the Acropolis.

The third building of the trilogy was the National Library. It was built on the other side of the University between 1885 and 1892 in the Doric style. This was the last building of Theophilos Hansen in Athens and was completed after his death in 1891 by Ernst Ziller.

As an old man Theophilos Hansen worked on the Great Exhibition Hall, the so-called Zappeion (1874-88). This complex was situated next to the Royal Gardens in Athens and was initially designed by the French architect François Boulanger. Building had begun in 1874 but following the death of Boulanger the commission was given to Theophilos Hansen. Hansen lowered the side wings and in the place of the central cupola envisaged by Boulanger he proposed the present Corinthian prostyle porch and the open circular court. Ernst Ziller was responsible for the supervision of the work in Athens.[43]

Up until the last years of his life, Theophilos Hansen was actively occupied with several projects for the city of Athens. His project for a museum to be sited south of the Acropolis between the Odeion of Herodes Atticus and the Theatre of Dionysos or his project for a summer residence for the Danish-born King George I of Greece are

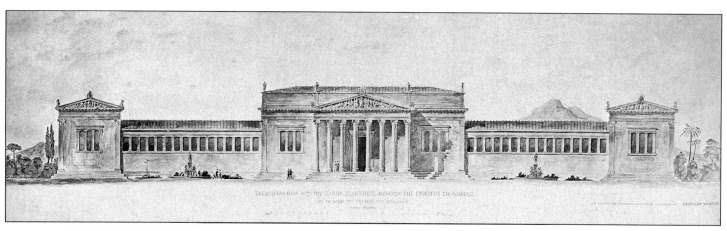

T HANSEN & F BOULANGER, ZAPPEION, ATHENS, 1874-88 (KB)

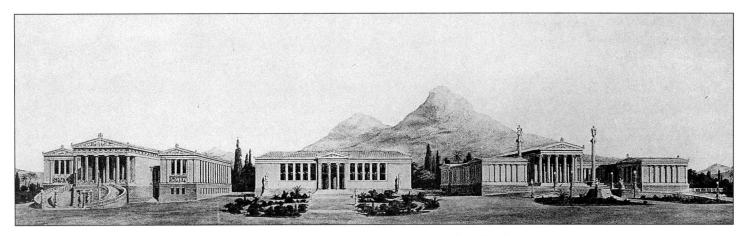

T & CH HANSEN, NATIONAL LIBRARY, 1885-92, UNIVERSITY, 1839-89, ACADEMY, 1859-87, ATHENS (KB)

examples of his fascination with the architectural ideals of Greek classical antiquity.

Notes

1 F M Tsigakou, *The Rediscovery of Greece*, London, 1981. Also W Hautumm (ed), *Hellas: Die Wiederentdeckung der klassischen Griechenland*, Cologne, 1983.
2 G Roux, *Karl Haller von Hallerstein*, Strasbourg, 1976, p 9 ff. A recent study of the expedition is given in *Paris, Rome, Athènes: le voyage en Grèce des architectes français aux XIXe et XXe siècles*, Paris, p 73 ff.
3 H Hübsch and F Heger, *Athen mit seinen Denkmählen*, Heidelberg, 1822. Also *Malerische Ansichten von Athen*, Darmstadt, 1823. H Hübsch also published *Über griechische Architektur*, Heidelberg, 1822.
4 Jørgen Hansen Koch's travel diary to Greece is in the Academy of Fine Arts, Copenhagen (21.9.1818–17.7.1819). There are letters sent from Koch to Brøndsted, written in London and Paris in 1822, about the publication of a book. The Royal Library, Copenhagen, NKS 1545, 2°.
5 H Bramsen and A Smith, *Danish Painting: The Golden Age*, London, 1984, p 184 ff.
6 *Schleswig-Holsteinisches Biographisches Lexikon*, I, 1970, p 235.
7 I Haugsted, 'The Architect Christian Hansen and Greek Neoclassicism' *Scandinavian Studies in Modern Greek*, No 4, 1980, p 63 ff. Christian and Theophilos Hansen, Family Letters, NKS 3954, 4° in the Royal Library, Copenhagen. See also letters from Christian Hansen to the Academy of Fine Arts in the National State Archive, Copenhagen.
8 J I Hittorff, *Architecture antique de la Sicile. . .* Paris, 1828. Biographies: K von Hammer, *Jacob Ignaz Hittorff*, Stuttgart, 1968 and M Fröhlich (ed), *Gottfried Semper*, second edition, Dresden, 1980.
9 The sculptor Ferdinand Pettrich (1798-1872) went to Athens to make a bust of King Otto ordered by his father Ludwig 1, of Bavaria. H Geller, *Franz und Ferdinand Pettrich*, Dresden, 1955, p 123, the bust depicted Fig 64.
10 I Haugsted, 'The Architect Christian Hansen: Drawings, Letters. . .' *Analecta Romana*, X, 1982, p 53 ff.
11 L Ross, E Schaubert, Chr Hansen, *Die Akropolis von Athen. . .*, Berlin, 1839.
12 D van Zanten, *The Architectural Polychromy of the 1830s*, New York and London, 1977, p 150 ff.
13 Letters from Bindesbøll to his brother Severin Bindesbøll in the Royal Library, Copenhagen, Add 297, 2°.
14 L Balslev Jørgensen, 'Thorvaldsen's Museum', *The International Journal of Museum Management and Curatorship*, 1984, p 237 ff.
15 *Scandinavian Studies, op cit*, p 72. See also J Travlos, *Neoclassical Architecture in Greece*, Athens, 1967, Fig 81.
16 *Scandinavian Studies, op cit*, p 70.
17 S O Fountoulakis, 'Der Plan der neuen Stadt Piräus', *Architectura*, 1977, p 46 ff.
18 I Haugsted, 'Universitet i Athen', *Architectura*, 7, 1985, p 7 ff.
19 R Wagner-Rieger and M Reissberger, *Theophil von Hansen*, Wiesbaden, 1980; V Villadsen, *Ribe Domkirke*, Ribe, 1974.
20 In the Academy of Fine Arts, Copenhagen, there are drawings and sketchbooks by Winstrup from Athens and the islands.
21 V Villadsen, *Studien über den byzantinischen Einfluss auf die europaische Architektur des 19 Jahrhunderts*, Hafnia, 1978, p 49.
22 Diary of Theophilos Hansen, 1838. The State Museum of Art, Copenhagen, Weilbach archive.
23 *Allgemeine Bauzeitung*, 1846, p 126.
24 September 1842. The Royal Library, Copenhagen, NKS 3954, 4°.
25 Villadsen, *op cit*, 1978, p 43 ff.
26 Villadsen, *op cit*, 1978, p 53, mentions also the military pharmacy built in Byzantine style in 1852, depicted in Travlos, *op cit*, Figs 93-94. Demolished 1934.
27 *Scandinavian Studies, op cit*, p 86 (ill), Inv No 3593.
28 Chr Hansen, Sketchbook 57, the Academy of Fine Arts, Copenhagen.
29 The Royal Library, Copenhagen, NKS 3341, 4°.
30 Wagner-Rieger, *op cit*, p 16 ff.
31 *Allgemeine Bauzeitung*, 1866, Waffen-Museum, (special issue).
32 Villadsen, *op cit*, 1978, p 54 ff.
33 Wagner-Rieger, *op cit*, p 43 ff, p 54 ff.
34 G Niemann und F V Feldegg, *Theophilos Hansen und seine Werke*, Vienna, 1893, p 92 ff; Th Hansen, *Erläuterung. . . Parlaments-gebäude*, Vienna, 1874, the text written in 1871.
35 Wagner-Reiger, *op cit*, p 111 ff.
36 Copy of a letter to G F Hetsch, 12.2.1850. The Academy of Fine Arts, Copenhagen.
37 I Haugsted, 'Skibsvaerftet i Triest', *Fabrik og Bolig*, 2, 1984, p 3 ff. See also N T Cholevas, *O architekton Christianos Hansen stin Tergesti*, Athens, 1982.
38 S Ellehøj and L Grane (eds), *Københavns Universitet, 1479-1979*, Vol IV, Copenhagen, 1980, p 240 ff.
39 *ibid*, p 244 ff.
40 K Hvidt, Sv Ellehøj, O Norn (eds), *Christiansborg Slot*, Vols I-II, Copenhagen, 1975, Vol II, p 203 ff.
41 *ibid*, p 216 ff. See also Villadsen, *op cit*, p 68 ff.
42 H H Russack, *Deutsche bauen in Athen*, Berlin, 1942, p 126 ff.
43 Cf Russack, *op cit*, p 144 ff. Also Travlos, *op cit*, Fig 73 ff.

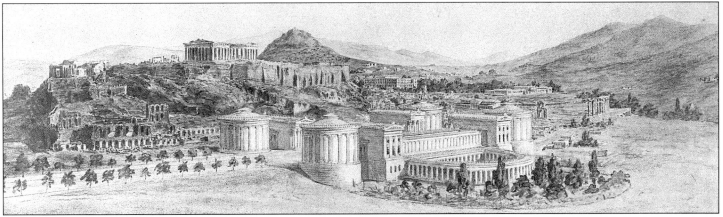

T HANSEN, PROJECT FOR A MUSEUM, ATHENS, 1888 (KB)

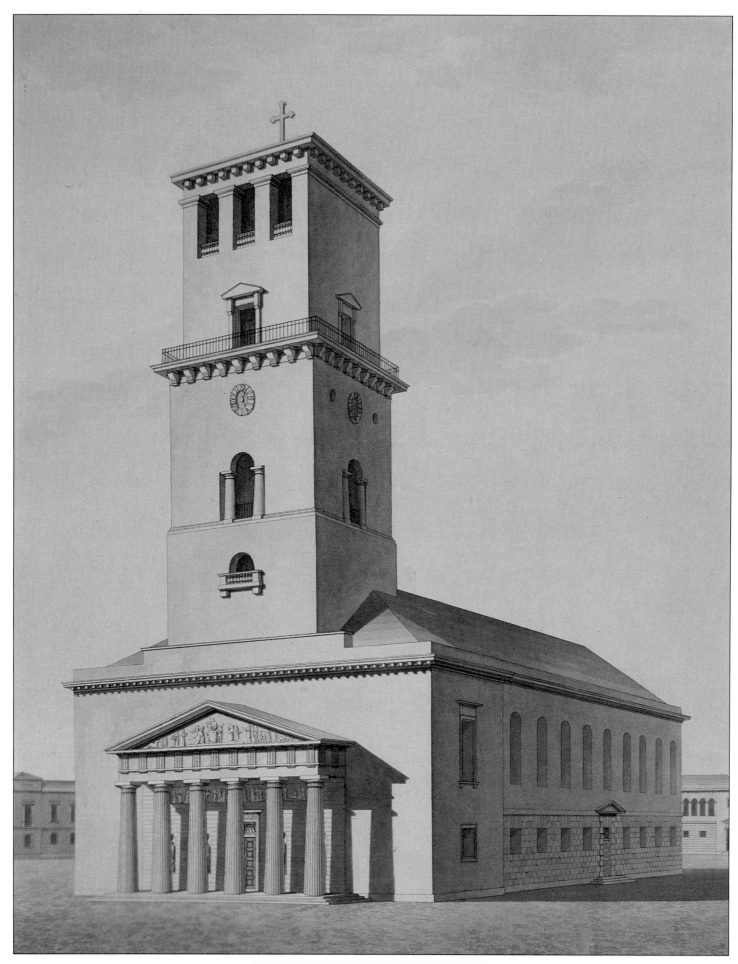

C F HANSEN, CHURCH OF OUR LADY, COPENHAGEN (KB)

THE CHURCH OF OUR LADY

Copenhagen 1817-29

C F Hansen

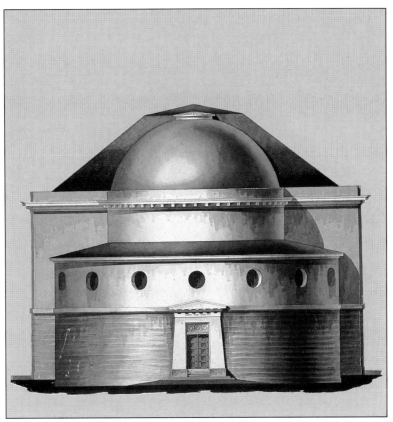

ELEVATION OF APSE (KB)

Following the bombardment of Copenhagen by the English fleet in 1807 the Baroque Church of Our Lady, standing in the middle of the 'Frue Plads', was left severely damaged. A resolution was soon reached as to who should be responsible for its rebuilding. In December 1808 Frederik VI awarded the commission to C F Hansen and declared that he should choose the style in which the new cathedral should be built.

C F Hansen retained much of the existing fabric and surprisingly little was altered in his Neoclassical rebuilding. The plans were formulated firmly within the context of overall proposals for the whole square, in which the Church occupied so central a position. During the period of its recon-struction (1808-19), work proceeded apace on a range of other buildings around the four sides of the square, which took the Church as their focal point, complementing and emphasising its forms and the moral and spiritual ideas inherent to it in a manner strongly reminiscent of the square around the Roman Pantheon. Hence the task of rebuilding acquired an enhanced signifi-cance calling for a particular sensitivity on the part of the architect.

The surviving part of the tower was not completed with a spire – as it had been earlier – but was classicised and a hexastyle Doric portico placed in front of it. The Gothic nave was widened and conceived as a grand basilica with unfluted Doric columns

supporting a massive coffered barrel-vaulted ceiling terminated by a great apse, where Bertel Thorvaldsen's statue of Christ was designed to stand. When Thorvaldsen was commissioned to carve the twelve Apostles an argument arose. Hansen's perspective of the Church shows that he conceived the statues as occupying the niches inside the piers of the nave but Thorvaldsen thought that they should stand 'in the round' and won the dispute. This gave a better sense of scale and greater depth to the interior while enhancing the feeling of antiquity.

In 1854, nine years after his death, the stark purity of C F Hansen's Neoclassicism was transformed by Christian Hansen who

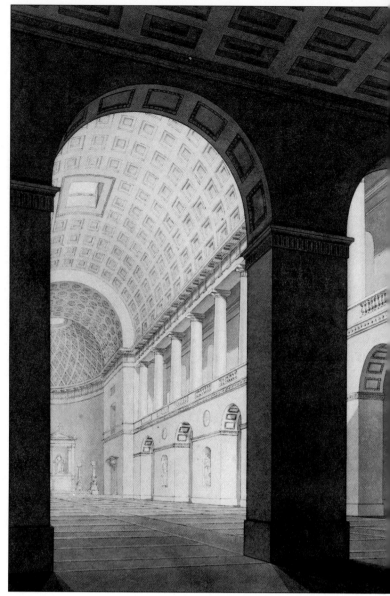

INTERIOR,

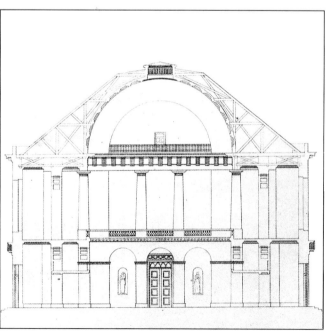

CROSS SECTION TOWARDS ENTRANCE (CH)

LONGITUDINAL SECTION

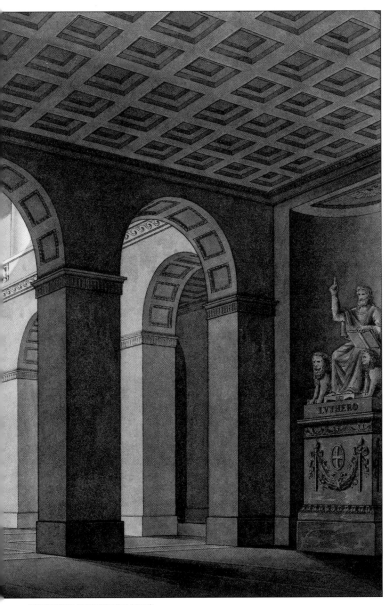

VIEW FROM VESTIBULE (CFA)

was eager to put into practice all he had learnt about polychromy during his earlier studies (on the Acropolis) in Athens. The flutes were painted onto the columns in amber. The nave was painted in a yellow ashlar colour; the architrave in vermillion, ultramarine and yellow ochre. Hansen also replaced the plaster coffers with timber ones and painted them in ultramarine with white stars in the manner of the Theseion.

In the recent restoration of 1975-79, the architect Vilhelm Wohlert, following Le Corbusier's principles of compositional purity, eliminated the polychromatic decoration and returned the interior to the spirit of C F Hansen's original design.

(CH)

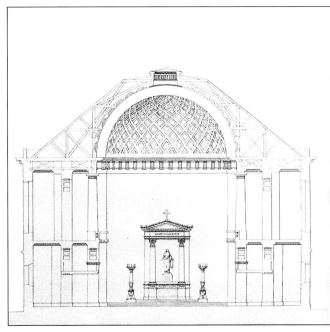

CROSS SECTION TOWARDS ALTAR (CH)

MAIN ENTRANCE FACADE (PHOTO L B JØRGENSEN)

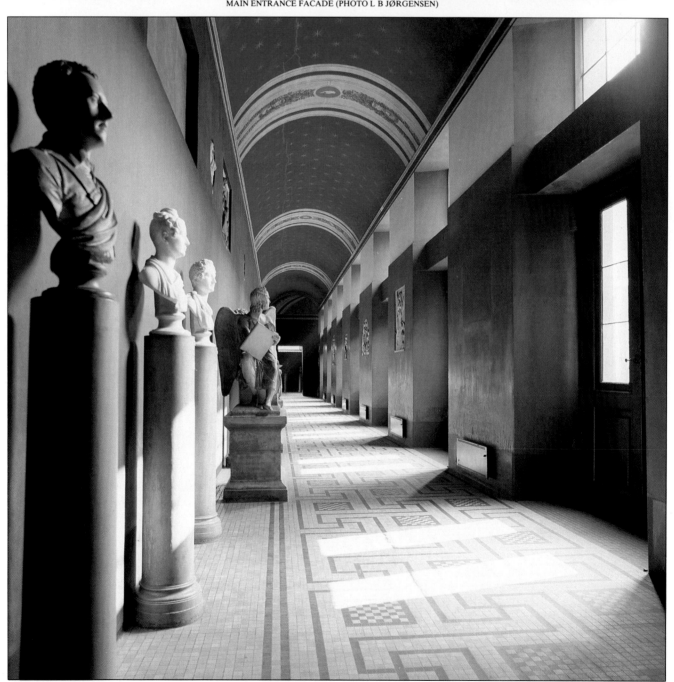

GROUND FLOOR CORRIDOR (KB)

42

THORVALDSEN MUSEUM
Copenhagen 1839-48
M G Bindesbøll

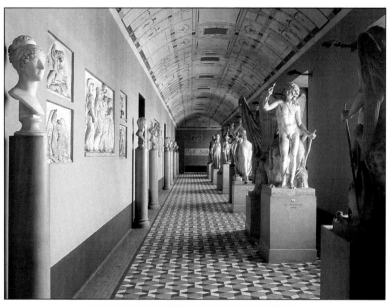

UPPER FLOOR CORRIDOR (PHOTO L B JØRGENSEN)

The Thorvaldsen Museum was designed and built in a period of national crisis. Denmark needed a cultural monument which would be expressive of the new constitutional democracy that would soon be established and, in the meantime, strengthen the national consciousness symbolically. The famous Danish sculptor Bertel Thorvaldsen who had lived and worked in Rome for almost half a century became the focus of attention. His Danish compatriots suggested to him that he could have his own

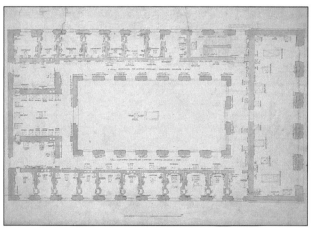

GROUND FLOOR PLAN (KB)

museum in Copenhagen where he would be the 'glory of the nation' and in 1834 the Copenhagen Art Association announced a competition for a museum on the site of Frederik's Church.

Amongst the entrants was Gustav Friedrich Hetsch, whose three-year sojourn in Rome between 1812 and 1815 had given him an experience of classical antiquity which led him to submit a scheme strongly reminiscent of the Roman Pantheon. But from the very beginning

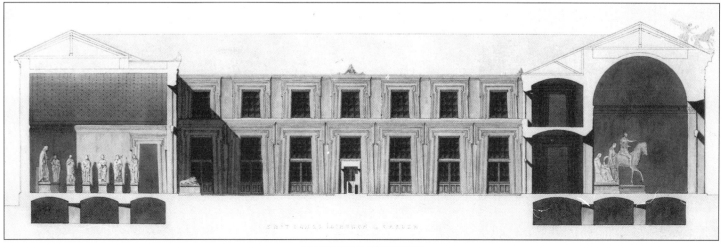

LONGITUDINAL SECTION (KB)

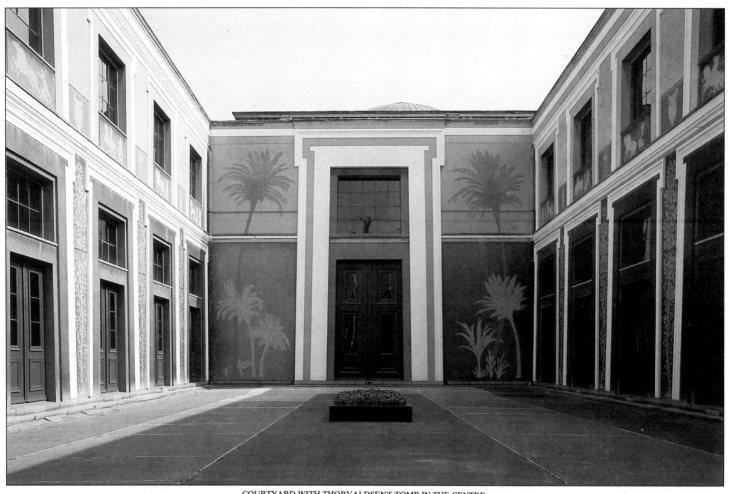

COURTYARD WITH THORVALDSEN'S TOMB IN THE CENTRE

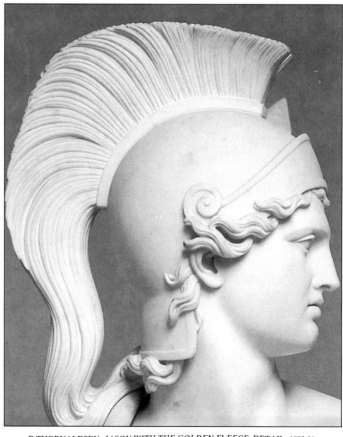

B THORVALDSEN, *JASON WITH THE GOLDEN FLEECE*, DETAIL, 1803-28

Thorvaldsen preferred Hetsch's student, the young Michael Gottlieb Bindesbøll, as the architect for his museum. In Bindesbøll he recognised a talented young architect who was willing to experiment with new ideas. However the Schinkelesque project which Bindesbøll had sent to the Academy did not impress Thorvaldsen, who did not want his sculpture to be outshone by the architecture and strongly believed that the exhibits in the museum should not be merely part of the interior decorating. He wanted sculpture and architecture to feature with equal prominence.

In 1834 Bindesbøll, having been awarded the Academy's travelling fellowship, left for Rome. Once there, he continued to work on his designs for the Museum in close collaboration with Thorvaldsen himself. In Rome Bindesbøll saw the marvellous possibilities of merging Roman, Greek and Egyptian styles whilst, on a later trip to

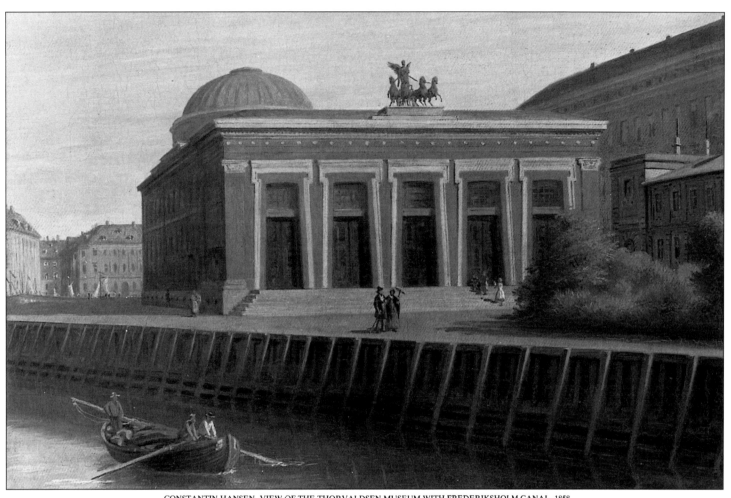

CONSTANTIN HANSEN, VIEW OF THE THORVALDSEN MUSEUM WITH FREDERIKSHOLM CANAL, 1858

B THORVALDSEN, *VENUS WITH THE APPLE*, DETAIL, 1813-16

Greece, he learned the polychromy of classical architecture, and from the outset conceived the Museum as a polychromatic structure. On the other hand, the sculptor himself favoured a building of simplicity with small rooms lit in the manner of a studio. These varied ideas had to be explored and brought together, so that all the lessons might be incorporated in a final design for the Thorvaldsen Museum which would satisfy both parties and constitute a national monument of artistic excellence.

Between 1813 and 1830, the leading architects Carl Petersen and Kaare Klint worked on the restoration of the Museum, and when Petersen came to design his Faaborg Museum, of 1912 to 1915, the Thorvaldsen Museum was the source of inspiration for a building which represented a turning point in the development of twentieth-century Scandinavian classicism.

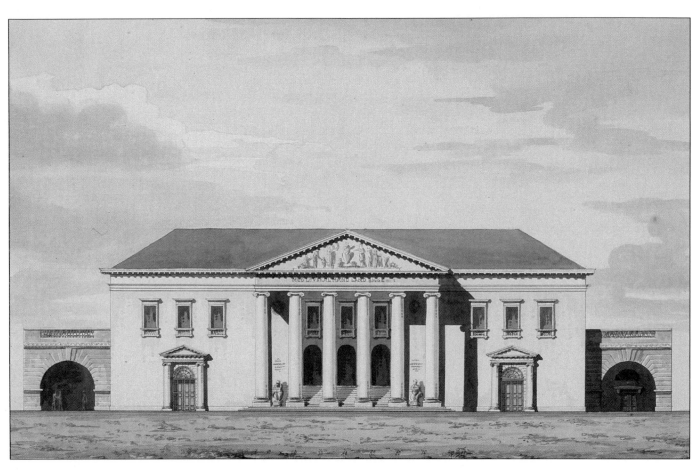

COURTHOUSE, FACADE (CFA)

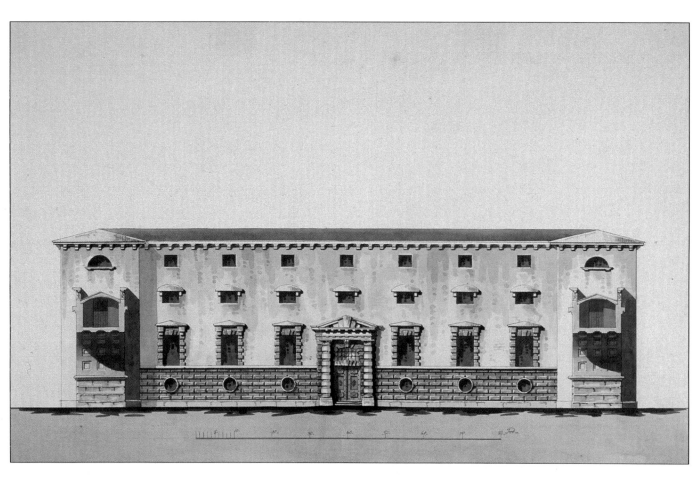

GAOLHOUSE, FACADE (CFA)

COURT & GAOL
Copenhagen 1805-15
C F Hansen

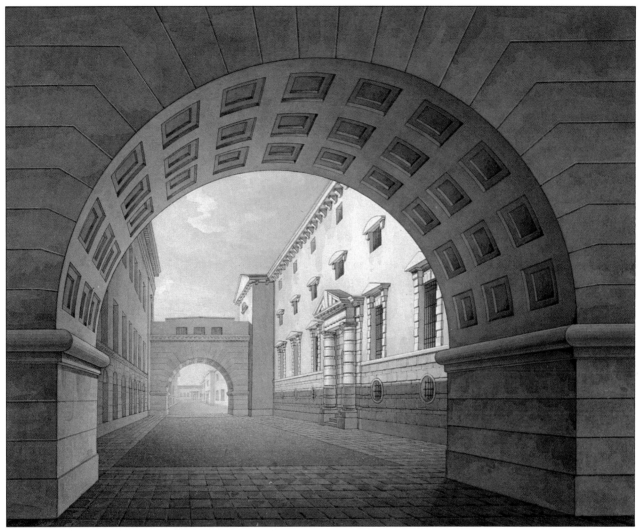

VIEW OF GAOLHOUSE THROUGH ARCHWAY (CFA)

The old Town Hall had been destroyed, like so much else, in the fire of Copenhagen in 1794. However, in spite of economic difficulties, much was rebuilt in a very short time. In 1800 the City Council appointed Carl Frederik Hansen as the architect of the new courthouse and prison buildings.

C F Hansen was familiar with the work of C N Ledoux and maintained ideas similar to the eighteenth-century theory of '*architecture parlante*' which informed many of the 'visionary' designs of the French architect. According to this theory, every building should have its own character that 'speaks' symbolically of its use.

Following these principles, C F Hansen conceived the design as comprising two different buildings connected by arched passages: a courthouse, which should serve to inspire respect and admiration for the law and confidence in justice and those who administered it; and a prison whose architecture was intended to intimidate and deter the most hardened criminal and serve as a constant reminder of the consequences of law-breaking. The Gaol was given a forbidding character with barred windows and heavily rusticated walls that call to mind the weight and gloom of Piranesian dungeons. In contrast, the simplicity of the massing of the Courthouse is further ennobled by the impressive hexastyle Ionic portico that adorns its facade.

C F Hansen was familiar with Ledoux's Town Hall design for Aix-en-Provence as well as with Palladio's reconstruction of the temples in Palestrina and Villa Badoer at Fratta Polesine – sources to which his design for the Court and Gaol in Copenhagen is indebted.

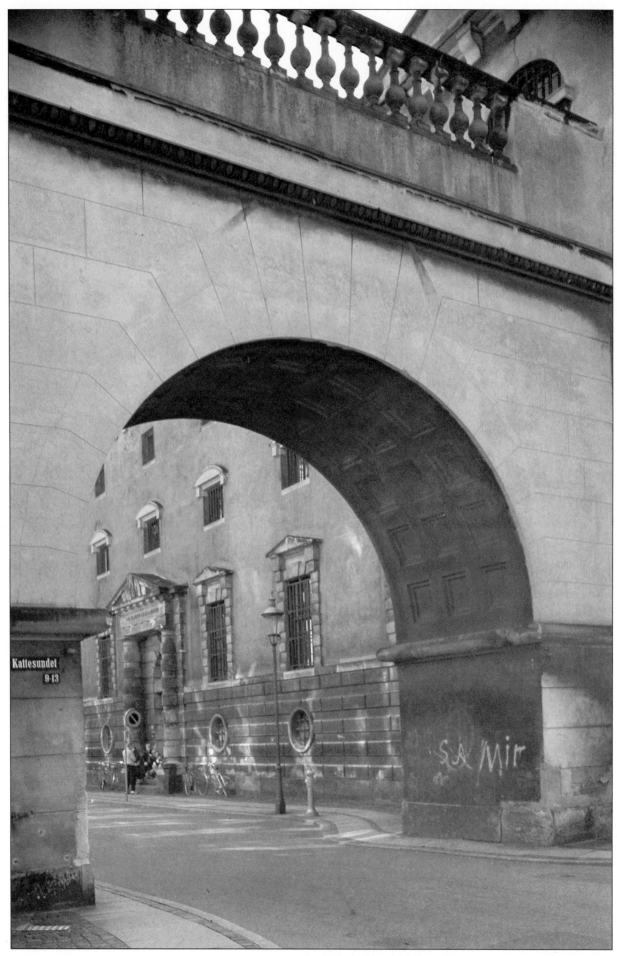

VIEW OF GAOLHOUSE FROM MAIN SQUARE (PHOTO L B JØRGENSEN)

GAOLHOUSE, DETAIL OF MAIN ENTRANCE (CH)

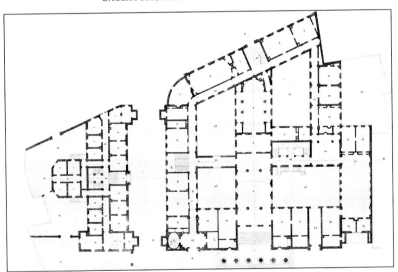

COURT- AND GAOLHOUSE, GROUND FLOOR PLAN (CH)

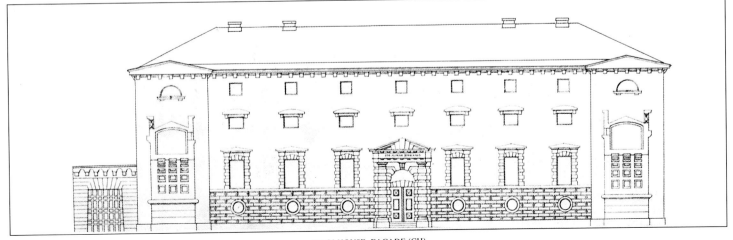

GAOLHOUSE, FACADE (CH)

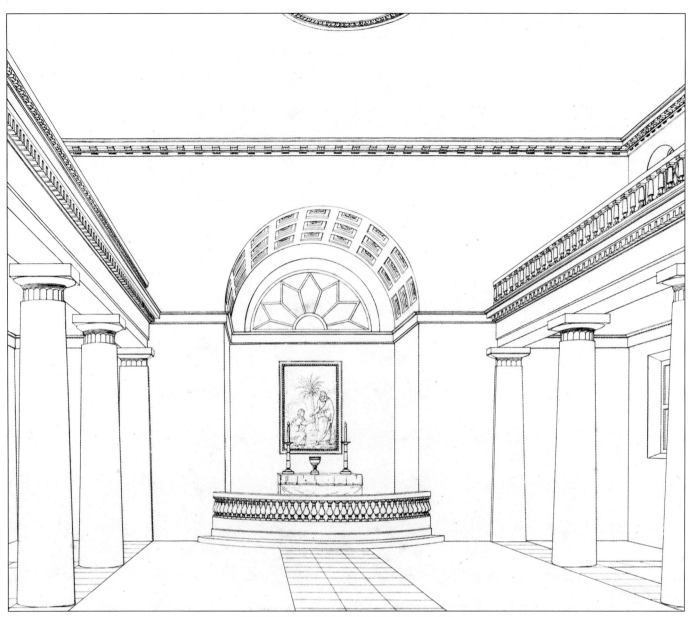

COURTHOUSE, PERSPECTIVE VIEW OF CHAPEL (CH)

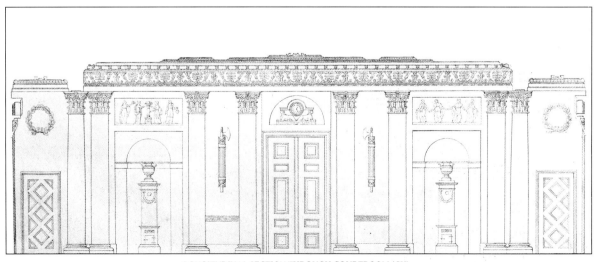

LONGITUDINAL SECTION THROUGH COURTROOM (CH)

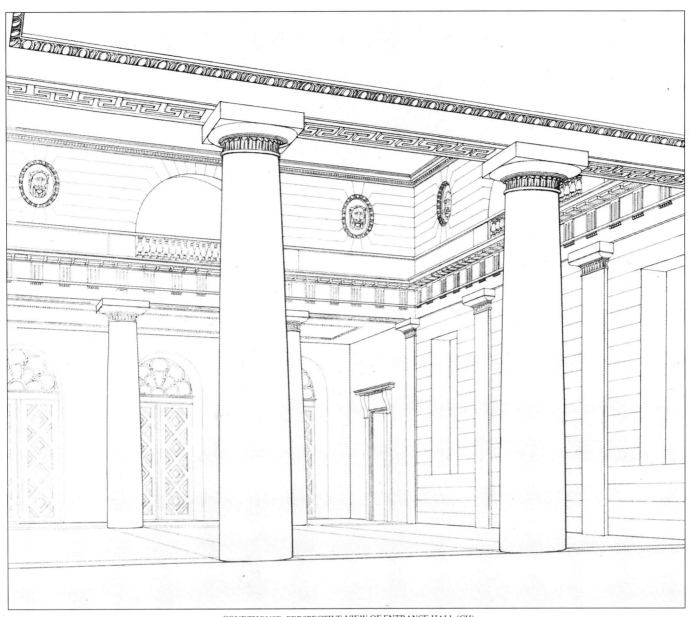

COURTHOUSE, PERSPECTIVE VIEW OF ENTRANCE HALL (CH)

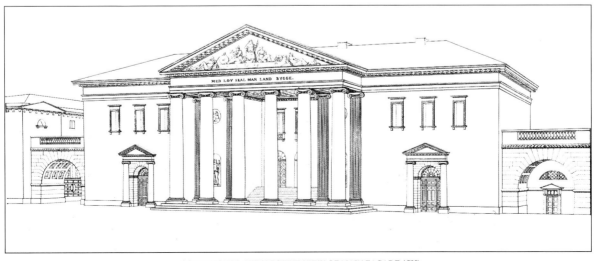

COURTHOUSE, PERSPECTIVE VIEW OF MAIN FACADE (CH)

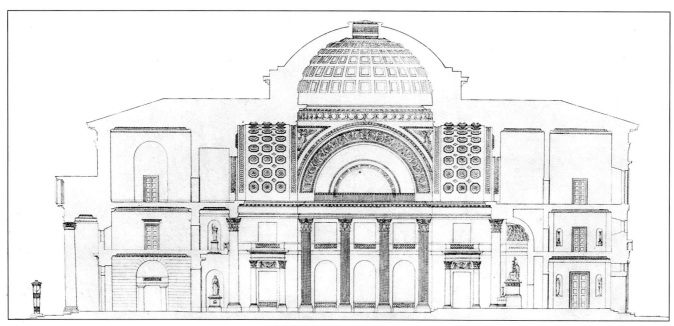

LONGITUDINAL SECTION (CH)

CROSS SECTION (CH)

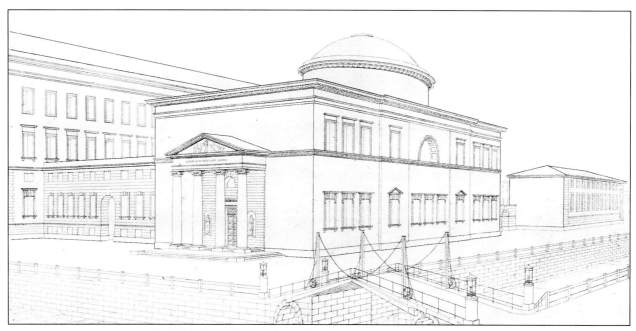

PERSPECTIVE VIEW OF THE SLOTSKIRKE FROM THE FREDERIKSHOLM CANAL (CH)

CHRISTIANSBORG SLOTSKIRKE

Copenhagen 1810-26

C F Hansen

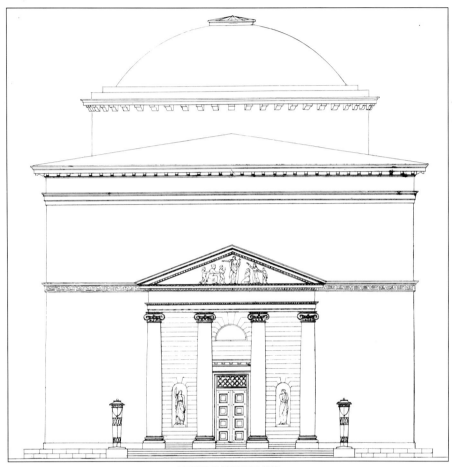

FRONT ELEVATION (CH)

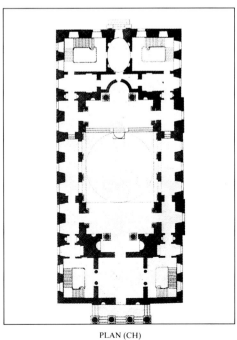

PLAN (CH)

The fire of 1794 destroyed Christiansborg Palace and its attached chapel. Plans for their reconstruction were not drawn up by C F Hansen until 1803 – no doubt partly as a result of the architect's heavy commitments in other rebuilding projects going on at the same time. Due to national financial problems, drawings were not presented again until 1810, and completion was not achieved until 1822, after twelve years of construction.

C F Hansen's design is based on the position of the earlier chapel and on the desire to allow the new building to read as free-standing. There is a drawing in one of his sketchbooks at the Royal Academy in Copenhagen of Vignola's St Andrea in the Via Flaminia, Rome, and it is quite likely that his project was influenced by this.

C F Hansen has resolved the rectilinear plan with his idea for a centralised space by the use of small barrel vaults at either end of the chapel and pendentives surmounted by a drum and cupola. Stylistically he strove for simplicity of detailing that would create a feeling of diginity.

The austerity of the facade owes something perhaps to the architecture of C N Ledoux, which exercised such a clear influence over Hansen's designs for the Courthouse and Gaol complex drawn up some years earlier.

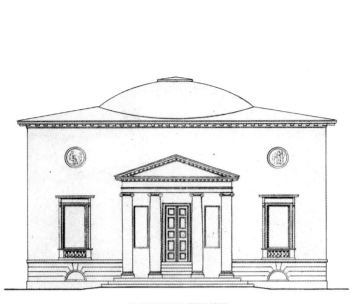

FRONT ELEVATION (CH)

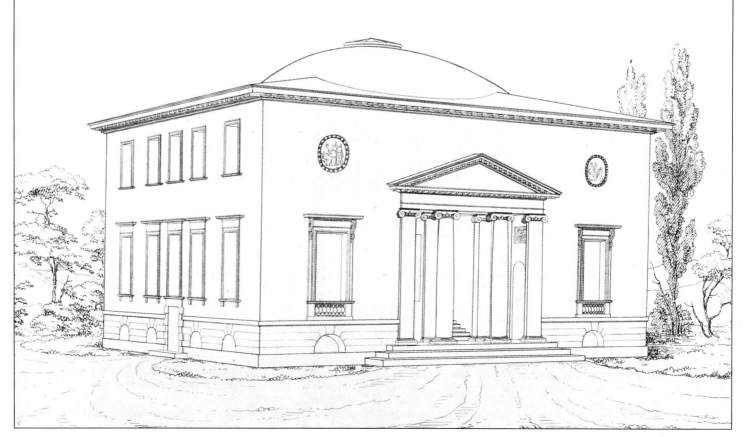

PERSPECTIVE VIEW (CH)

HOUSE IN ALTONA
C F Hansen 1804-06

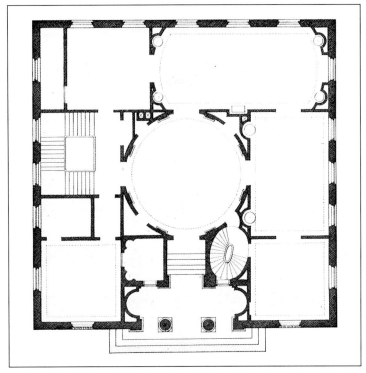

GROUND FLOOR PLAN (CH)

As a young architect, Carl Frederik Hansen worked in Altona where he designed and built a number of villas and town-houses in a neo-Palladian manner.

Hansen gave his buildings a simple mas-sing with few, but expressive, details. The beauty of form and proportion was more important to him than the elegance of decoration or the opulence of expensive materials.

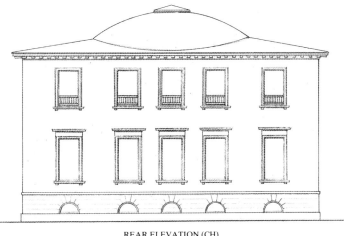

REAR ELEVATION (CH)

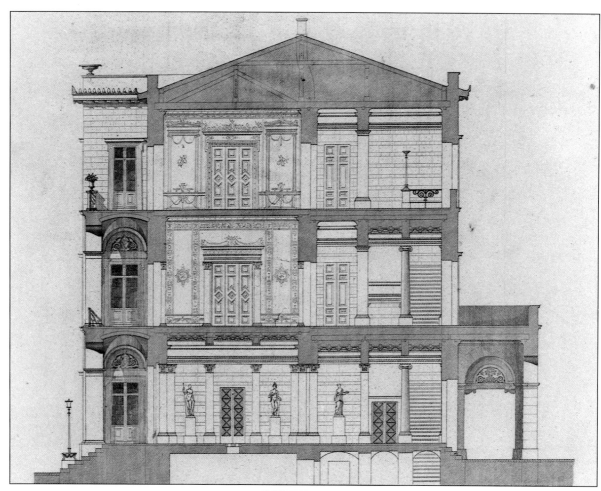

CROSS SECTION (AB)

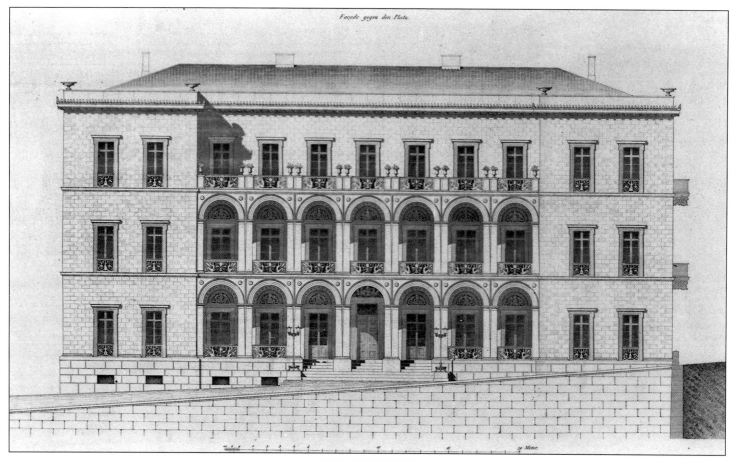

Façade gegen den Platz.

FRONT ELEVATION (AB)

DEMETRIOU HOUSE
Athens 1842-43
Theophilos Hansen

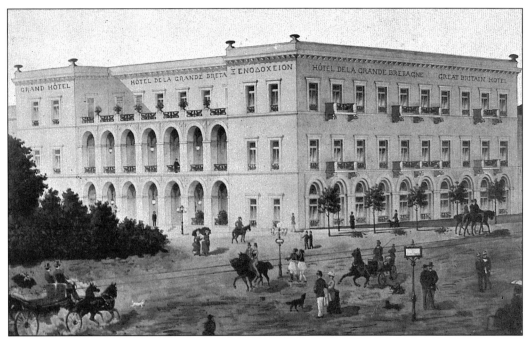

VIEW OF DEMETRIOU HOUSE FROM THE ROYAL PALACE (KB)

Theophilos Hansen had studied Renaissance classicism and the way in which it had been recently interpreted by Karl Friedrich Schinkel. What he admired in Schinkel's work was the architect's ability to impart to the language of the Renaissance a cosmopolitan opulence, thus creating a symbol for the nineteenth-century bourgeoisie.

The Athens house of the wealthy merchant Demetriou was designed in a spirit intended to evoke the secular virtues of the houses of Italian Renaissance banking families. While the building is organised symmetrically with its main entrance facing Constitution Square, Hansen introduces a system of superimposed arcuated loggias that impart a playful character appropriate to a private residence. Similarly, the volumetric simplicity of the side elevation is animated iconographically by the arcuated ground floor and the balconies above. Internally the house was decorated extensively with polychromatic motifs.

The Demetriou House shows how essential Renaissance classicism was to the nineteenth-century bourgeoisie who wanted to represent their European cosmopolitanism through architecture. The house has since suffered extensively by the subsequent addition and renovations. Today it is used as the Hotel Grande Bretagne.

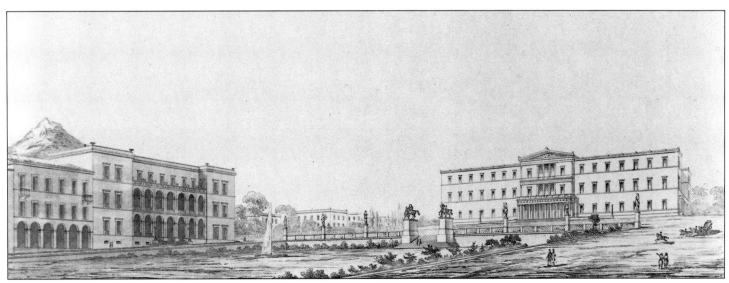

DEMETRIOU HOUSE (LEFT), AND THE ROYAL PALACE (RIGHT) (AB)

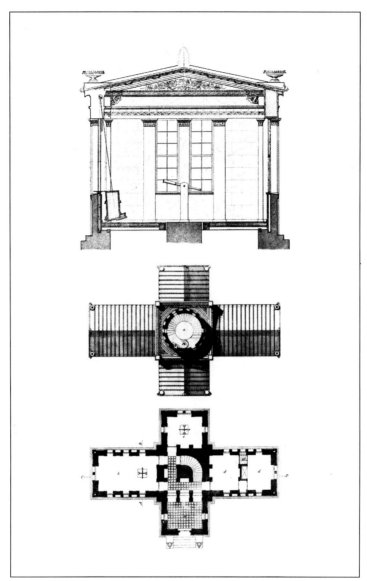

CROSS SECTION AND PLANS (AB)

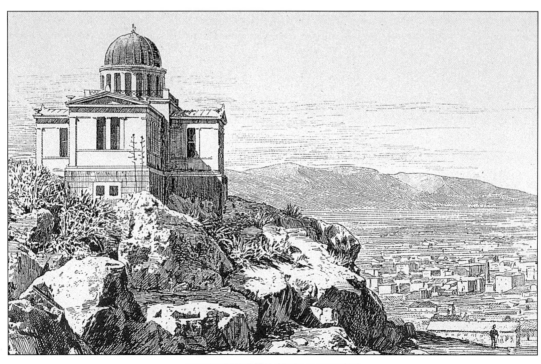

THE OBSERVATORY, GENERAL VIEW (TH)

THE OBSERVATORY
Athens 1842-46
Theophilos Hansen

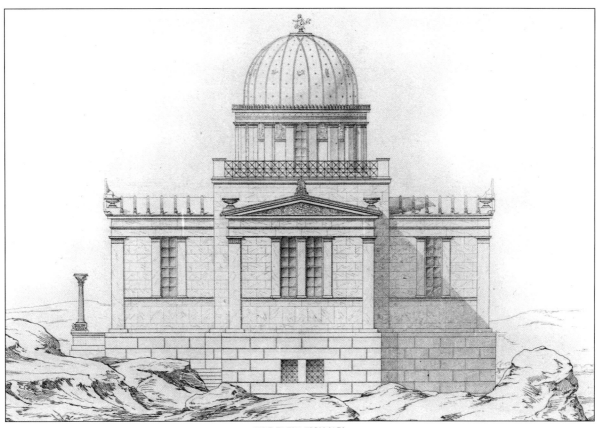

SIDE ELEVATION (AB)

Plans for the new Observatory in Athens were initially drawn up by Eduard Schaubert. His neo-Byzantine style, however, was considered by King Otto inappropriate for a national monument so close to the Acropolis and the commission was given to Theophilos Hansen for his classical scheme.

Theophilos Hansen succeeded in satisfying with equal skill the functional requirements of the observation dome on the one hand and, on the other, the symbolic programme necessary for a civic building representing the newly founded Greek State. His close study and first hand knowledge of the classical buildings

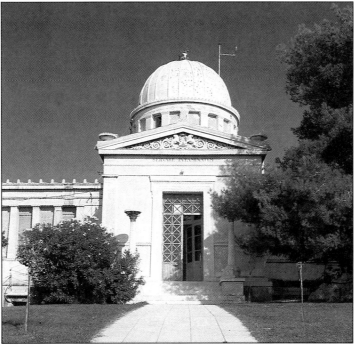

VIEW TOWARDS ENTRANCE (PHOTO D PORPHYRIOS)

on the Acropolis had taught him the beauty of classical proportions as well as the sophistication and sensuous richness of polychromy. The profile and proportions of the main Observatory entrance, as well as those of the architraves, pilasters and capitals used throughout the building, are inspired by the Parthenon and the Erechtheion. The materials used are limestone from the Hill of the Nymphs and Pentelicon marble, whilst the friezes are decorated with themes taken from vases of Greek antiquity. The result is a total work of art that is intimately bound up in Greek architectural and cultural history.

VIEW OF INTERNAL PERISTYLE (NA)

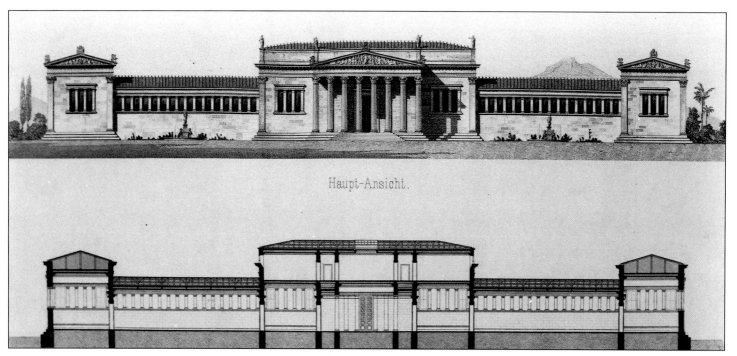

Haupt-Ansicht.

FRONT ELEVATION AND CROSS SECTION (AB)

THE ZAPPEION
Athens 1888
F R Boulanger & Theophilos Hansen

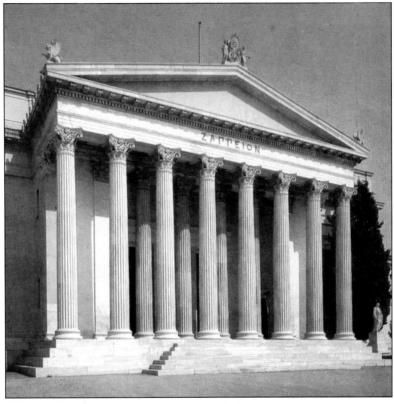

FRONT PORTICO (NA)

As an old man Theophilos Hansen worked on the Great Exhibition Hall, or Zappeion, so called after Constantine Zappas who financed the building. This complex is situated next to the Royal Gardens in Athens and was initially designed by the French architect François Boulanger. Building had begun in 1874 but in 1880, following the death of Boulanger, the commission was given to Theophilos Hansen. Hansen lowered the side wings and in place of the central cupola envisaged by Boulanger he proposed the present Corinthian prostyle porch and the open circular peristyle court.

Hansen published Boulanger's plans together with his own design changes in the *Allgemeine Bauzeitung* of 1884.

Even in his old age, Theophilos Hansen recalled the advice he was given by his brother Christian while still a student at the Academy of Fine Arts in Copenhagen: '. . . in my opinion, you ought to study first Greek classical antiquity. It is only then . . . [that you can] understand Gothic, Renaissance or any other way of building . . . Exercise in composition and study the effect of volumes, profiles, shapes and colours . . .'

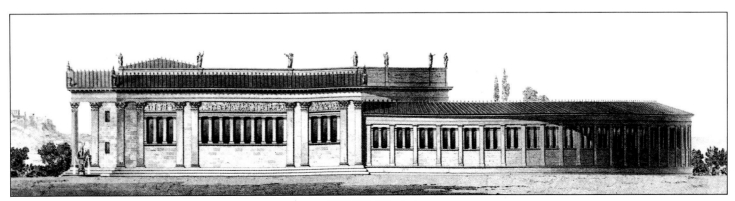

SIDE ELEVATION (AB)

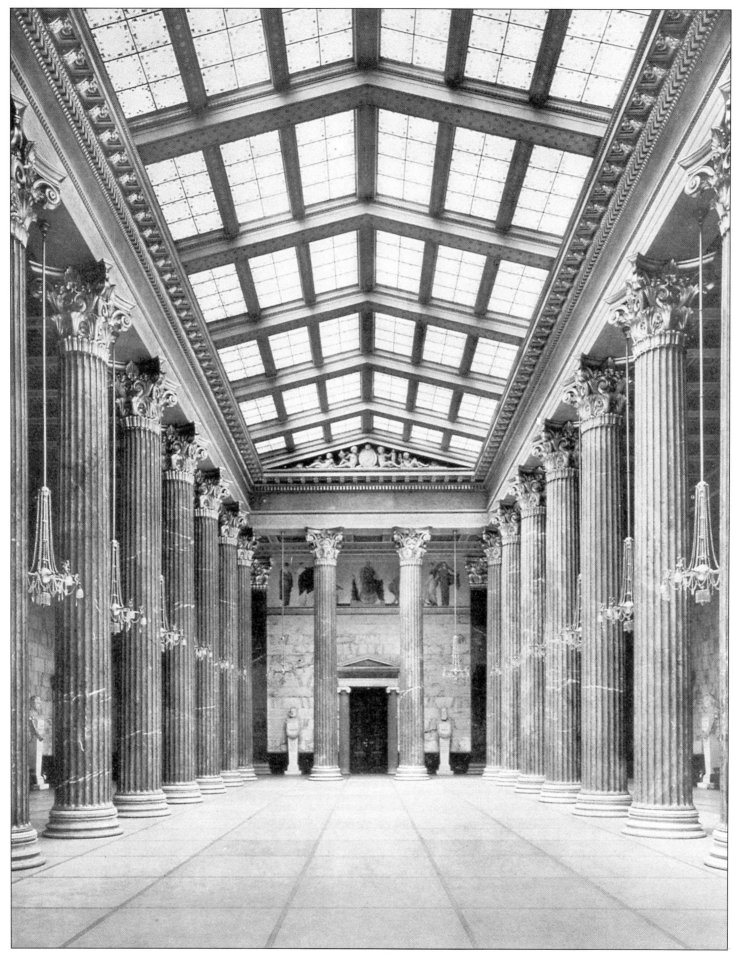

CENTRAL PERISTYLE (DK)

VIENNA PARLIAMENT

1874-84

Theophilos Hansen

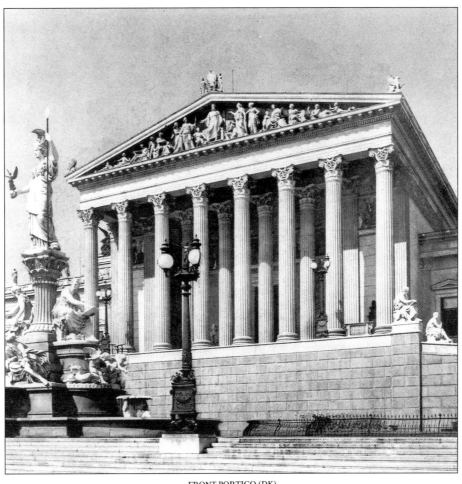

FRONT PORTICO (DK)

In 1860 the Austrian liberals took over political control of the Hapsburg empire and made Vienna its political, economic and cultural centre. Förster's Ringstrasse Plan was meant to celebrate the triumph of constitutional secular culture.

The Parliament was the most prestigious and widely acclaimed building in Vienna by Theophilos Hansen, who naturally viewed the commission as an extraordinary opportunity in which to prove his architectural talent and creative interpretation of the language of classical antiquity he had studied and loved for so many years.

The plans for the Parliament changed as the liberals' power grew. Initially the two legislative houses were to be in separate buildings and executed in different styles: Greek classical for the Upper House and Roman Renaissance for the Lower House. Following the Austro-Prussian War of 1866, however, a more liberal constitution led to the unification of the two Houses in a 'single monumental building of splendour'.

The building comprises the Upper and Lower Houses, offices and common reception rooms for both chambers, all organised around a central peristyle Hall. The adoption of Greek classicism for the whole complex symbolised the parliamentary integration of peers and people.

The sheer size of the commis-

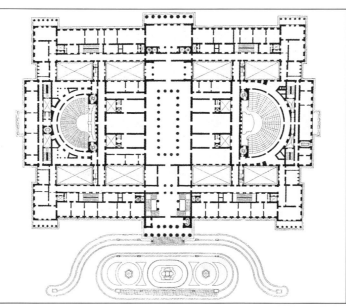

PRINCIPAL FLOOR PLAN (DK)

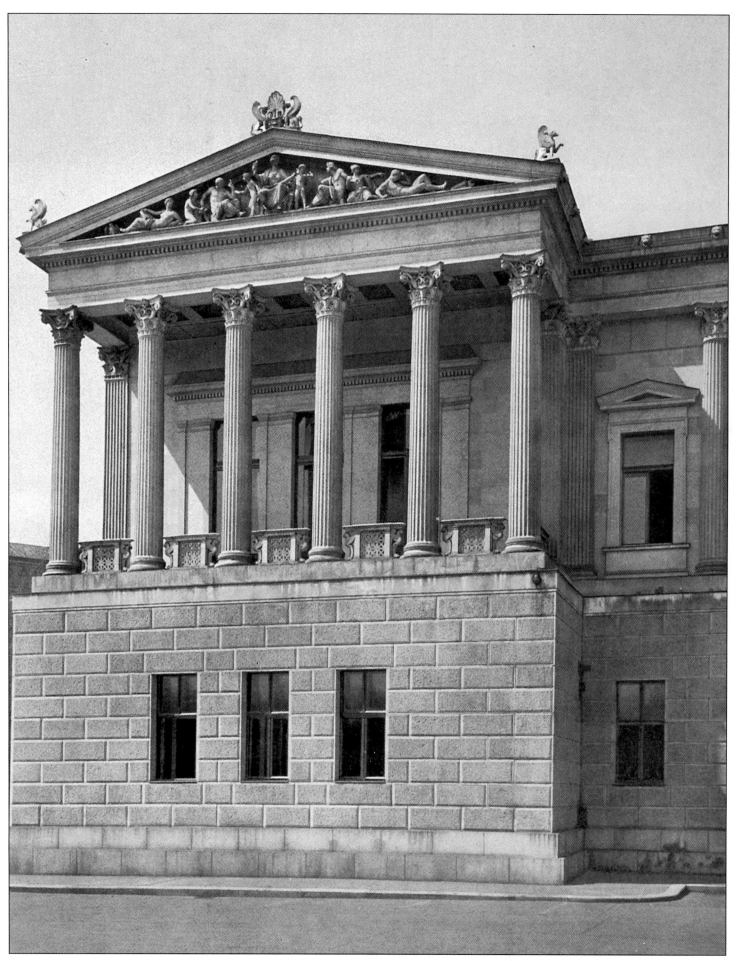

FRONT ELEVATION, NORTH PORTICO (DK)

POLYCHROMATIC STUDY (DK)

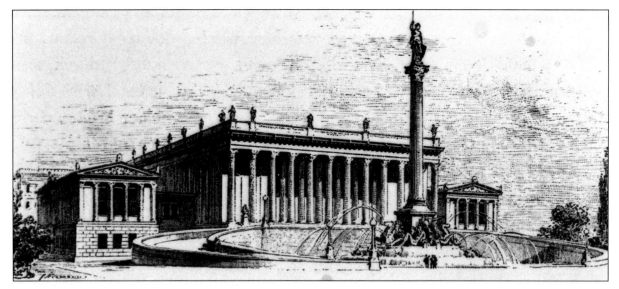

T HANSEN, PROJECT FOR THE HERRENHAUS, 1865 (TH)

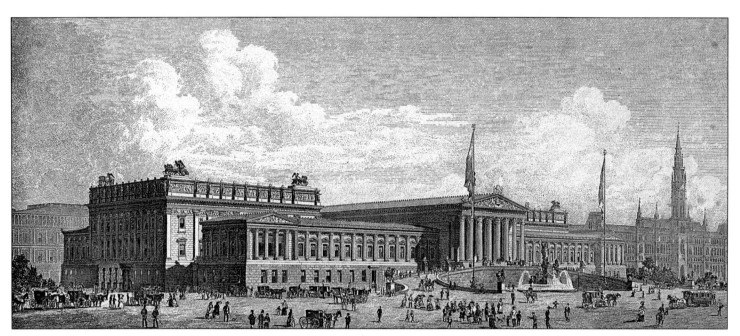

T HANSEN, VIENNA PARLIAMENT, GENERAL VIEW

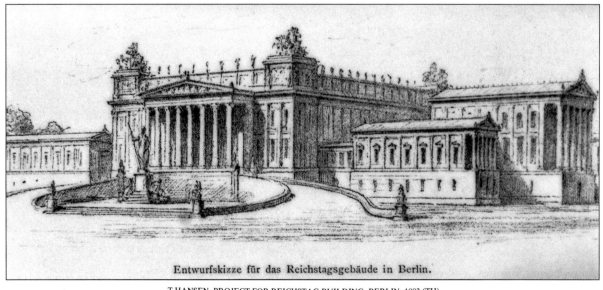

Entwurfskizze für das Reichstagsgebäude in Berlin.

T HANSEN, PROJECT FOR REICHSTAG BUILDING, BERLIN, 1883 (TH)

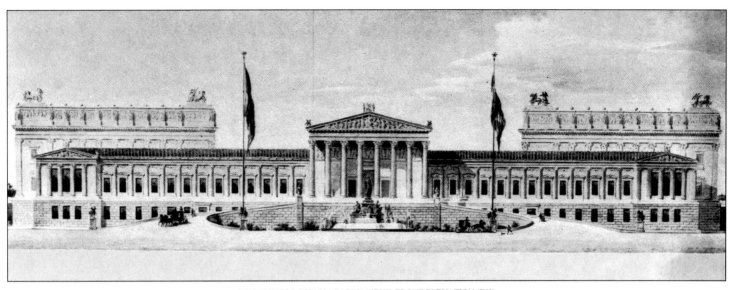

PROJECT FOR VIENNA PARLIAMENT, FRONT ELEVATION (DK)

sion presented Hansen with a serious architectural problem of massing and scale. Hansen chose to break down the building volumetrically by articulating its mass into interlocking and superimposed pavilions. This strategy of additive massing can also be seen in his National Library and Academy of Athens, and in his projects for the Berlin Town Hall, the Museums-Insel, or the Museum south of the Acropolis.

The Vienna Parliament is also a singular example of the unity that can be achieved between architecture, sculpture and polychromy. 'Architecture on its own . . .', remarked Theophilos Hansen, '. . . is not free unless it unites with sculpture and painting; and nowhere

T HANSEN VIENNA PARLIAMENT, 1874-84, DOOR IN SIT-
ZUNGSSAALE. MEASURED DRAWING BY L O'CONNOR

else has this been achieved better than in the noble simplicity of Greek classical antiquity'. The pediment sculptures of the Corinthian portico and the side wings, the statues of classical historians along the central ramp, as well as the statues completing the skyline of the two auditoria attest to the importance that Hansen gave to the sculptural enrichment of architecture. The statue of Athena in the centre of the ramped approach alluded to the goddess of wisdom as protetrix of the polis and was meant to serve as a symbol for the liberal unity of politics and rational culture. Furthermore, it was Hansen's intention that the exterior be as polychrome as the rooms inside, but this was never carried out.

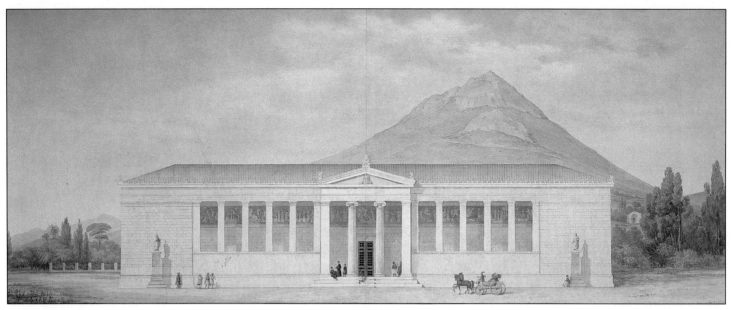

FRONT ELEVATION (KB)

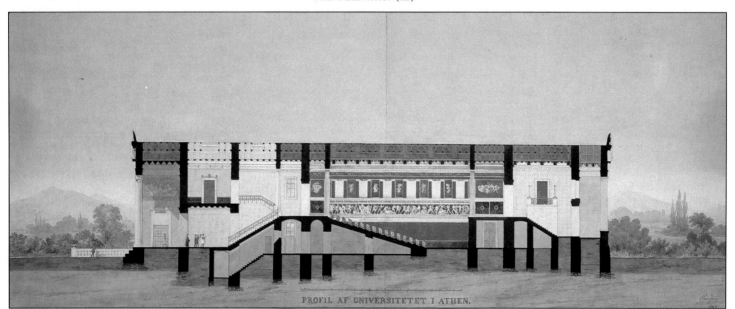

PROFIL AF UNIVERSITETET I ATHEN.

LONGITUDINAL SECTION (KB)

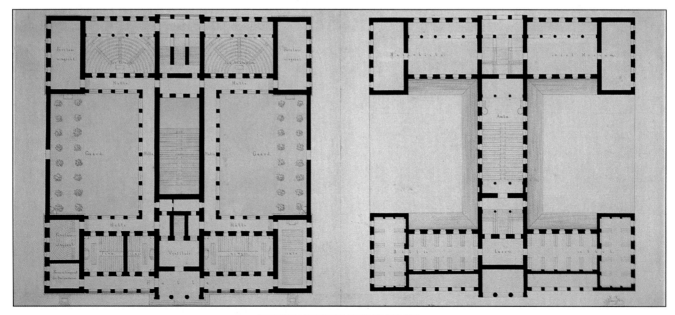

GROUND AND FIRST FLOOR PLANS (KB)

ATHENS UNIVERSITY

1839-89

Christian Hansen

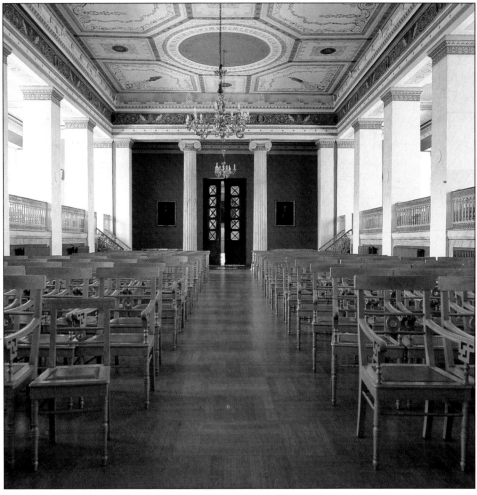

THE GREAT HALL (KB)

The University was the first public building of the newborn Greek State. Its stylistic treatment was to prove of seminal importance to the strengthening of Greek national consciousness. At the same time it became a prototype for a Hellenic classicism in contrast to the models of imperial Prussian architecture.

Christian Hansen assimilated in an inventive manner the noble simplicity and calm serenity of classical Greek antiquity. He had worked on the 1835-37 restorations of the Acropolis and studied there the technical details of classical architecture and the polychromy of its temples. The architectural details of Hansen's University are indebted to

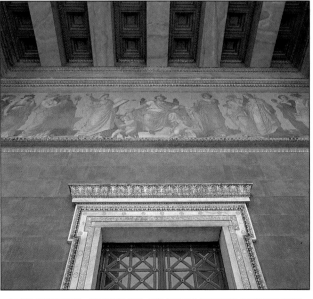

MAIN ENTRANCE, ARCHITRAVE AND FRIEZE (PHOTO L B JØRGENSEN)

the north portico of the Erechtheion, the Propylaea and the Temple of Nike Apteros.

The Ionic entry portico is combined with a trabeated loggia that reveals the organisation of the plan behind while establishing a frontality that engages spatially the whole facade. The unadorned wall surfaces flanking the loggia terminate the composition without unnecessary volumetric articulations. The wall of the loggia is painted in red and the paintings of the frieze, the work of Karl Rahl, depict King Otto surrounded by the Muses. Externally, the building is finished in render, the architectural elements being in white and green marble.

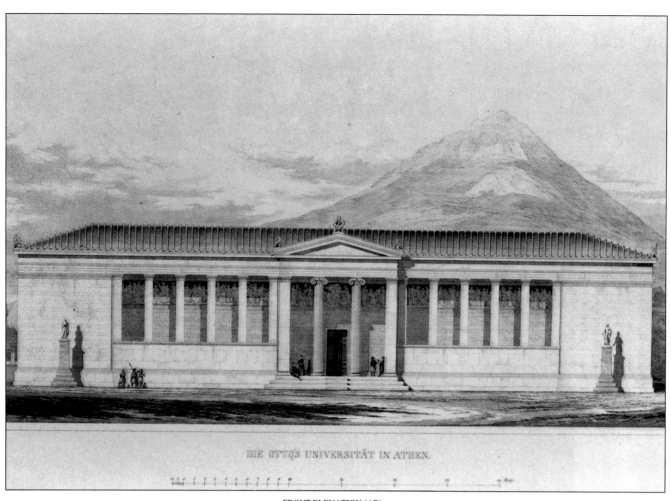

DIE OTTOS UNIVERSITÄT IN ATHEN.

FRONT ELEVATION (AB)

LECTURE ROOM FURNITURE (AB)

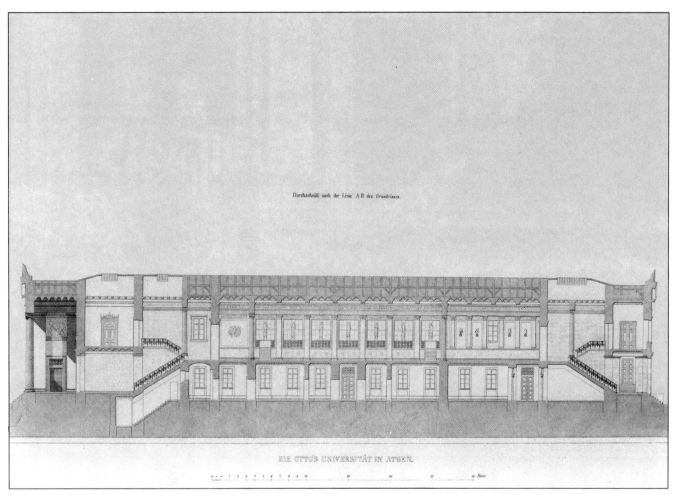

LONGITUDINAL SECTION (AB)

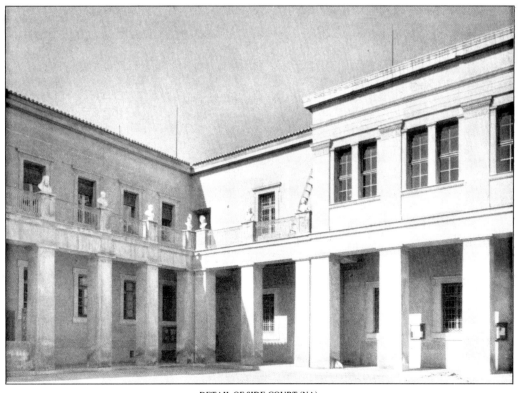

DETAIL OF SIDE COURT (NA)

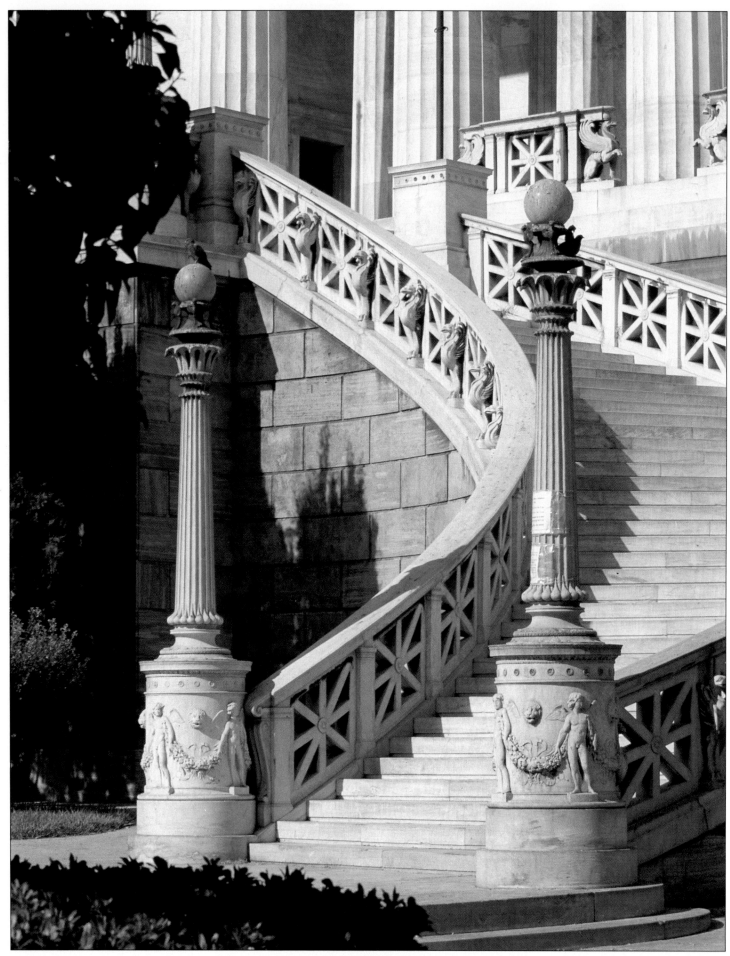

FRONT PORTICO STAIRCASE, DETAIL (PHOTO D PORPHYRIOS)

NATIONAL LIBRARY
Athens 1885-92
Theophilos Hansen

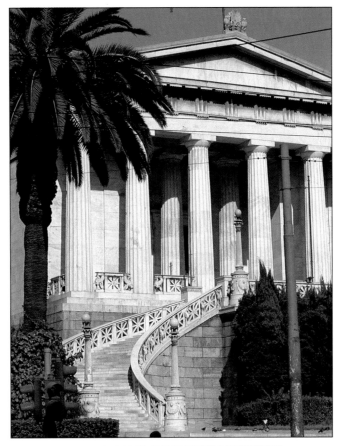

FRONT PORTICO STAIRCASE (PHOTO D PORPHYRIOS)

In 1868 the University of Athens considered building a laboratory next to the University building of Christian Hansen. The architect Ernst Ziller, appalled by the prospect of a shapeless extension, urged Kyriakos, the Vice-Chancellor of the University, to cancel his plans and instead adopt the earlier (1859) proposal by Theophilos Hansen for an 'Athenian Trilogy' comprising University, Academy and Library.

After lengthy discussions involving Ziller, Kyriakos, the Prime Minister Trikoupis and Gregor Ypsilantis, the Greek ambassador to Vienna, it was agreed to invite Theophilos Hansen to submit drawings for the University Library.

Hansen was so honoured by the invitation that he agreed to design the new Library at no cost, as a gesture of appreciation for all that Greek antiquity had given him. Ernst Ziller supervised the work in Athens.

The front of the Library has a steep double staircase that leads to the main entrance – much like Theophilos Hansen's unexecuted project for the Archaeological Museum. The hexastyle portico is in the Doric order. In plan the Library comprises three interconnected rectangular volumes. The central volume houses the reading room and has a glazed roof supported by an Ionic peristyle. The side wings flanking the reading room house the book stacks.

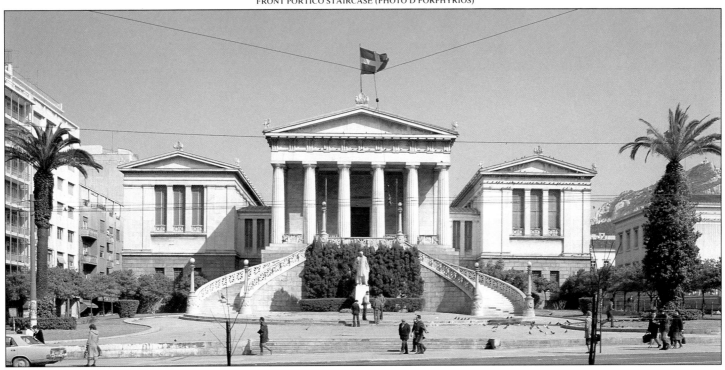

FRONT ELEVATION (PHOTO D PORPHYRIOS)

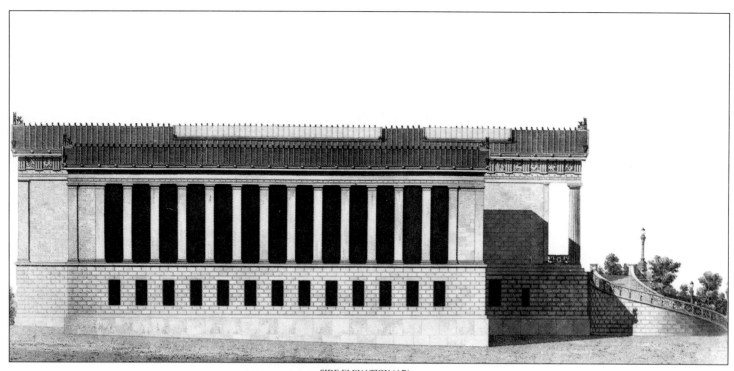

SIDE ELEVATION (AB)

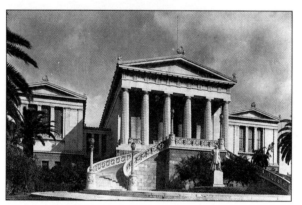

VIEW OF PORTICO AND SIDE PAVILIONS (BM)

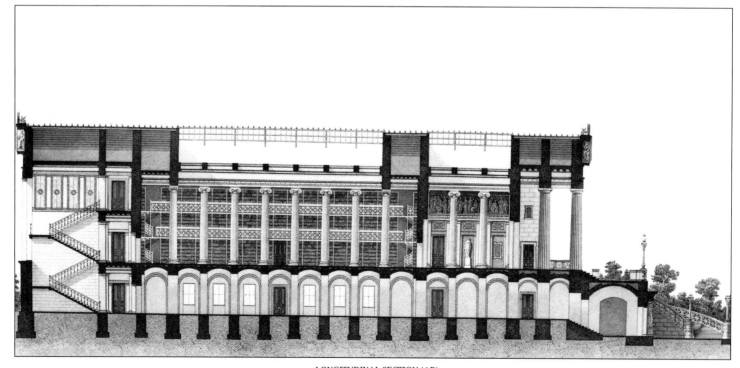

LONGITUDINAL SECTION (AB)

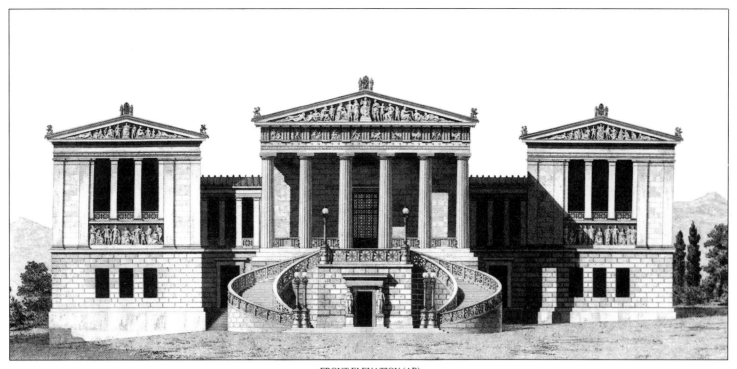

FRONT ELEVATION (AB)

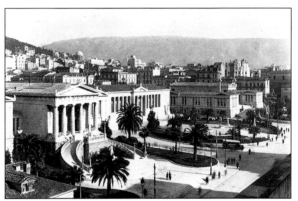

THE NATIONAL LIBRARY, UNIVERSITY AND ACADEMY (NA)

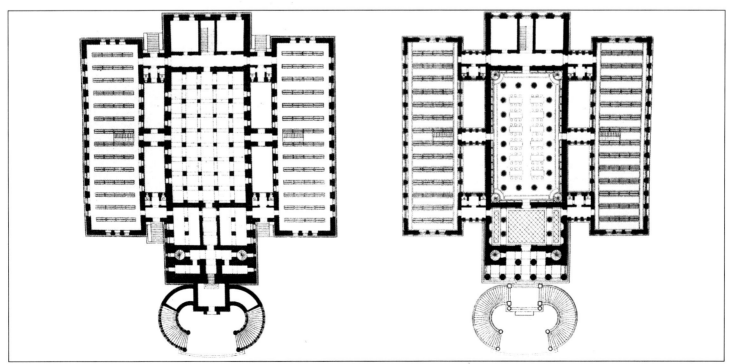

GROUND AND PRINCIPAL FLOOR PLANS (AB)

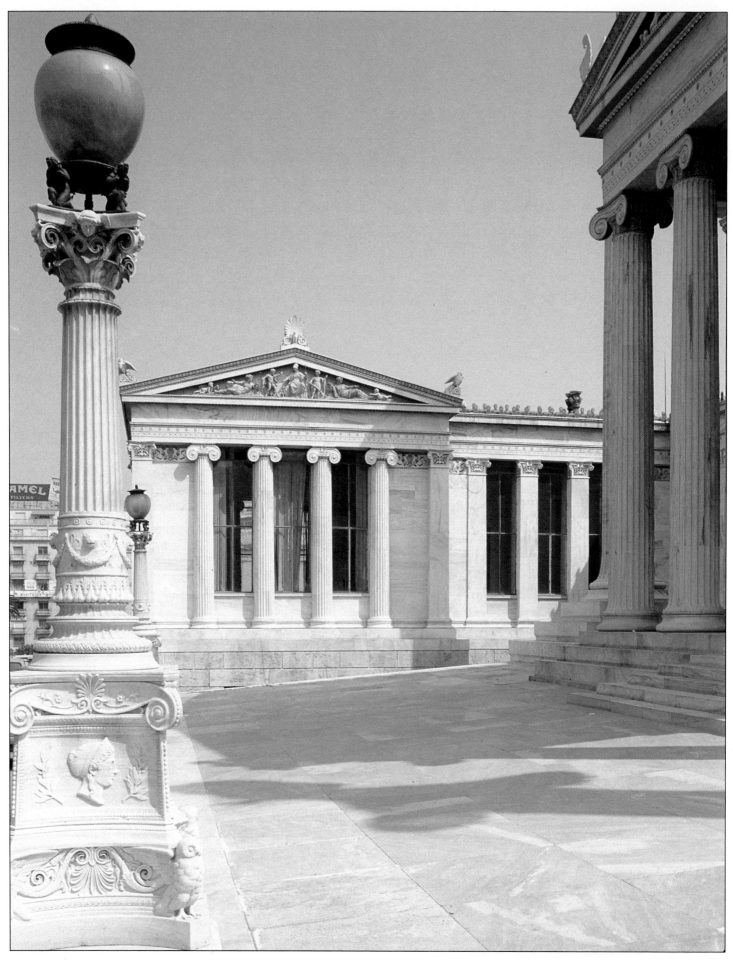

CANDELABRUM, SIDE WING AND FRONT PORTICO (PHOTO L B JØRGENSEN)

ATHENS ACADEMY

1859-87

Theophilos Hansen

DETAIL OF IONIC CAPITAL (PHOTO L B JØRGENSEN)

The Academy of Athens is perhaps the most genial compositional scheme of Theophilos Hansen . The central volume is conceived as an amphiprostyle temple with hexastyle Ionic porticos. The cella symbolically houses the large assembly hall. The wings that flank this central volume are terminated with pavilions which inflect towards the centre. The plastic versatility of the composition is further enhanced by the front and rear courts which allow the various independent masses of the building to recede or advance perspectively.

The assembly hall, still preserved in its original state, has its walls decorated with gigantic figures depicting the adventures of Prometheus, bearer of life. These were painted by Christian Griepenkerl, a student of Karl Rahl. The other rooms as well as the friezes externally are painted and gilded in the polychromatic palette of Greek classical antiquity. A recent restoration has brought out the brilliance of colour when seen against the Attic sky. The sculptures of the pediments of the front portico depict the birth of Athena and are the work of the Greek sculptor Drossis.

SIDE WING, PILASTER DETAIL (PHOTO L B JØRGENSEN)

DETAIL OF PENCIL DRAWING OF FRONT ELEVATION (AK)

FRONT ELEVATION (TH)

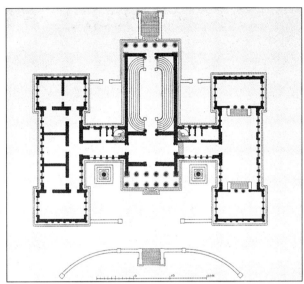

PRINCIPAL FLOOR PLAN (TH)

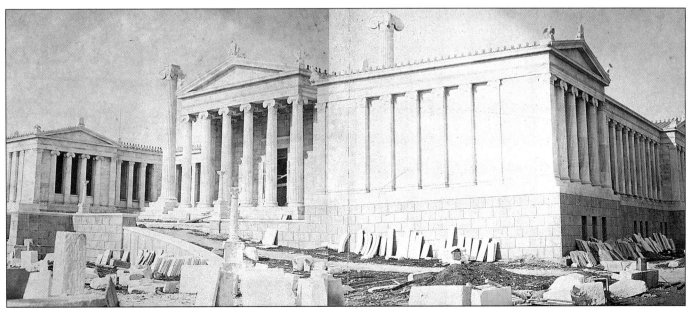

PHOTOGRAPH TAKEN DURING CONSTRUCTION (KB)

79

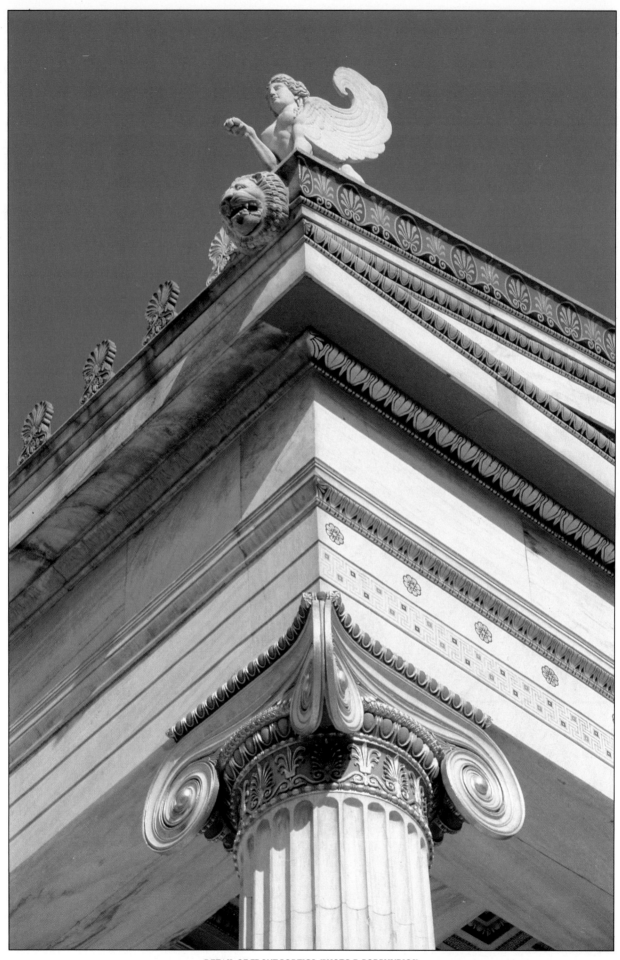

DETAIL OF FRONT PORTICO (PHOTO D PORPHYRIOS)